French Salon Artists
1800-1900

Richard R. Brettell

The Art Institute of Chicago

and Harry N. Abrams, Inc., Publishers, New York

Executive Director of Publications, The Art Institute of Chicago:
Susan F. Rossen
Edited by Lyn DelliQuadri, Associate Editor

Designed by Lynn Martin, Chicago
Typeset in Berkeley by Paul Baker Typography, Inc., Evanston, Illinois
Printed and bound in Italy by Arti Grafiche Amilcare Pizzi, S.p.A., Milan

Photography credits: Principal photography by Terry Shank, Department
of Photographic Services, The Art Institute of Chicago, with additional
photography by Jaroslaw Kobylecky and Kathleen Culbert-Aguilar.

Back cover: *Still Life: Corner of a Table,* 1873, by Henri Fantin-Latour
Front cover: Detail of *Still Life: Corner of a Table*

Library of Congress Cataloging-in-Publication Data

Art Institute of Chicago.
 French Salon artists, 1800-1900.

 1. Painting, French – Catalogs. 2. Painting, Modern – 19th century –
France – Catalogs. 3. Salon (Exhibition: Paris, France) – Catalogs. 4. Société
des artistes français. Salon – Catalogs. 5. Painting – Illinois – Chicago –
Catalogs. 6. Art Institute of Chicago – Catalogs. I. Brettell, Richard R.
II. Title.
ND547.A74 1986 759.4'074'017311 86-73030
ISBN 0-8109-0946-4
ISBN 0-8109-2350-5 (pbk.)

SALON ART IN THE NINETEENTH CENTURY

The word "Salon" appears on virtually every page of the vast bibliography devoted to painting and sculpture in nineteenth-century France. In the first half of the century, the Salon was the annual arena in which the period's greatest painters fought for pre-eminence before a vast, opinionated audience. During these years, this government-sponsored exhibition was the setting for renowned battles between Théodore Géricault and the classicist students of Jacques Louis David; between J.A.D. Ingres and Eugène Delacroix; and between the conventions of the French Academy of Fine Arts and Gustave Courbet's realism, Edouard Manet's bold innovations, and the "New Painting" championed by the Impressionists.

At mid-century, Courbet, wanting to present his work to the public on his own terms, began to think of alternatives to the Salon and even rented temporary exhibition halls. In the century's last decades, with the Impressionists in ascendance, the Salon became synonymous with the establishment, "the enemy," and most advanced artists, including Camille Pissarro, Edgar Degas, and Alfred Sisley, defiantly refused to send their work to these great state-sponsored art fairs. By the century's end, when Post-Impressionists Paul Gauguin, Georges Seurat, and Edouard Vuillard were exploring color theory and unorthodox subjects and styles, the Salon had become virtually irrelevant.

A definition of the Salon is complex and elusive. At its simplest level, the Salon was a state-sponsored exhibition of contemporary art in all major media – painting, sculpture, graphic arts, photography, and architecture – chosen by a jury of artists, which was selected in a manner approved of by the government. The practice of mounting such an exhibition began shortly after the formation of the Royal Academy of Fine Arts in Paris in 1667, but the early shows featured only the works of members of the Academy and were not surveys of the totality of contemporary French art. By the eighteenth century, the field widened, and the exhibitions began to be regularly scheduled. However, it was not until the nineteenth century, often called the great age of exhibitions, that the Salon took on the character of an international trade show of the arts, and artists of all nations were invited to submit their works.

Nineteenth-century Salons, with which this volume is concerned, were so vast that no single viewer could take one all in. Held biennially at the beginning of the century, after 1830 it became, with a single exception, an annual event, as Paris consolidated its position of authority in the art world. The numerous surviving catalogues, reviews, and illustrations make it clear that the effect of the Salon was one of sheer aesthetic abundance. The Salon of 1859, for example, included 3,045 paintings and 849 works in other media, all by living artists, and this was far from the largest nineteenth-century Salon. Paintings were crowded together on the walls of the immense galleries of the Musée du Louvre or the Palace of Industry on the Champs Elysées; drawings, prints, and sculptures were jammed into corridors and smaller spaces. As if in imitation of art, life entered the exhibitions in the form of such extraordinary numbers of people that there was scarcely air to breathe or room to maneuver. Here was a visual spectacle, and an intensely capitalistic and urban event.

Visitors to today's great museum "blockbusters" can have some sense of the pressing crowds that attended Salons. People streamed in, particularly on Sundays, when the small admission charge normally assessed was waived and the public was admitted free. Most students of nineteenth-century art have seen the famous group of lithographs by Honoré Daumier caricaturing the hordes of Salon-goers;

many of his lesser-known contemporaries, such as Pierre Gavarni and Amédée Charles Henri Cham, were just as prodigious in their graphic satires of these mob scenes. Indeed, the expression *tout Paris*, or "all of Paris," used so frequently during the second half of the nineteenth century, applied to no other artistic event as it did to the Salon.

Perhaps because of its vastness and its governmental sanction, the Salon has been viewed as an adversary to artistic freedom in most histories of modern art. Even the most casual student of modern French art knows that many of Manet's greatest paintings were rejected by the Salon juries, and we have long admired the independent entrepreneurial efforts of the Impressionists to set up their own exhibitions. Although the Salon was absolutely essential for the careers of David, Ingres, Delacroix, and even Courbet, it became so bloated and confused by mid-century that many artists followed the example of Courbet in seeking alternative viewing environments and, in so doing, repudiated the aesthetic standards implied by the Salon.

The aesthetic standards that prevailed in these government-sponsored exhibitions during the nineteenth century were at best unclear. The French government changed more than a dozen times during the course of the century, and the changes were often significant. Certain administrations were defiantly socialist and democratic, while others were just as extreme – and as sincere – in their royalist ideology. For that reason, the aesthetics of a particular regime could be totally opposite to those of another: the favored art in the royalist France of 1824 meant something quite different from that preferred in the revolutionary years 1848-49 or during the bourgeois "empire" of 1860. These differences, indeed, these

startling contrasts, are readily apparent to any reader who flips through the pages of this book.

A serious study of Salon art in the nineteenth century reveals that, in spite of its official status and conservative reputation, this annual exhibition displayed a wide variety of artistic styles and played an essentially beneficial role in the careers of many artists long thought to have been rejected by it. In fact, the careers of the artists of the Barbizon School, the major aesthetic rebels of mid-nineteenth-century France, would have been impossible without the exhibition opportunities provided by the Salon. Moreover, many of the greatest late nineteenth-century artists, including Claude Monet, Auguste Renoir, and even Odilon Redon, made important works expressly for that annual exhibition. The nineteenth-century Salon, in fact, cannot be indicted for its exclusivity, but rather for its inclusivity and inability to create and maintain aesthetic standards.

Many Salon juries were dominated by artists like Delacroix and Camille Corot, who fought for the inclusion of the new and worked to compromise with their more conservative confreres rather than to arrive at a real consensus. Decisions made by Salon juries were usually "deals," compromises made among the judges. No Salon would have been entirely acceptable to any one of its jurors. Virtually every Salon contained masterpieces as well as miles of mediocrity – a mediocrity that encompassed every aesthetic and political persuasion. Some of the masterpieces were made by advanced painters, others by artists we have been taught to ignore or vilify.

All of this leads us to one inescapable conclusion: that there is no such thing as official Salon art. For every purported description of Salon paintings – that they were smoothly painted or that they tended to have allegorical subjects – there are hundreds, even thousands, of exceptions. For every year in

which the jury was dominated by conservative artists, there was another in which advanced artists held sway.

Salon juries, contemporary artists, writers, and members of the art-going public often differed greatly in their opinions, but there was, among them, one common denominator – they cared passionately about the Salon. Most artists worked throughout their careers to make works that would be noticed and reviewed there, and the major writers of the era created an independent literary genre in the form of Salon criticism. Their essays-reviews were called "salons." Authors from Stendhal to Geoffroy and including Baudelaire and Zola wrote about the Salon exhibitions as if their "salons" – their reviews – were synonymous with the real Salons.

Interestingly, no single history of the Salon in French art exists. Some historians have studied individual artists in and out of the Salon. Others have studied Salon criticism, sometimes focusing on the writings of a particularly important or influential critic. More recently, attention has been given to the dissection and analysis of certain particularly crucial Salon exhibitions, like that of 1824, which included not only Ingres, Delacroix, and Paul Delaroche, but also the English painter John Constable.

French Salon Artists does not aim to survey the history of the Salon, but rather to showcase the particular collection of nineteenth-century French art formed by The Art Institute of Chicago. In order to understand the book, several explanations are in order. First, it was my decision to include only the work of French artists or those whose careers were spent almost entirely in France, despite the fact that the Salon was an international exhibition and included many works by foreign artists who wanted to be seen in what was then the art capital of the world. I also decided to include only pictorial art, even though sculpture played a large role in Salon exhibitions. Both these decisions were dictated by the Art Institute's collections, which are extremely rich in nineteenth-century French Salon painting and graphic arts.

The addition of graphic arts is a unique feature of this volume. Most histories of modern art are histories of painting, with some attention paid to sculpture, but virtually none given to the graphic arts, both printed and drawn works on paper. This is surely unfair. Artists of the caliber of Delacroix, Ingres, Courbet, Manet, and Redon made prints and drawings for exhibition at the Salon, and many of these have been relegated to unnecessary obscurity by the fixation of scholars and the general public on the history of painting. While I have aimed here to be more inclusive, I must acknowledge that my selection of graphic arts is relatively small, considering both the depth of the Art Institute's holdings and the importance of the subject. I felt it was necessary for me to choose works on paper that would reproduce strongly enough to "stand" in the same book beside some of the Art Institute's greatest canvases. For the most part, this is an impossible demand to put on a print or even a drawing, more delicate by nature and, in many cases, made to be seen in smaller rooms than paintings and to be assessed with a different sensibility.

Perhaps the most important decision that was made in the compilation of this volume was to include several works that were not exhibited at the Salon. Whether or not an artist made a painting specifically for the Salon, most nineteenth-century French artists produced works of art within an aesthetic and institutional structure dominated by it. For that reason, I have made selections that are either

replicas or free adaptions of works exhibited at the Salon by an artist; in still other instances, I have chosen paintings or graphic arts by artists that are not substantially different from those that they sent to the Salon. For instance, such works by Manet are included here, in addition to the one major painting in our collection, *The Mocking of Christ* (p. 61), that he made expressly for Salon exhibition in 1865. The accompanying texts make clear the precise relationship of each work of art to the Salon.

The end result of my method of selection is to offer the reader a sample of important paintings, drawings, and prints produced by artists who received the sanction of the Salon during its halcyon years. The Art Institute's collection of Salon art is an excellent one, but not in any sense a representative one. Absent are the large historical subjects paintings by David, Delaroche, François Gérard, or Théodore Chassériau, which dominated the Salons in the first half of the century. Nor are there the major Romantic canvases of immense scale by Delacroix or Claude Aimé Chenavard.

Many of the most important Salon paintings and drawings in the collection of the Art Institute were actually made by avant-garde artists, whose work we associate with the rebellion against the Salon: the celebrated artists of the Barbizon School — Jean François Millet, Théodore Rousseau, and Narcisse Virgile Diaz de la Peña — as well as the outspoken Courbet, Manet, Pissarro, Degas, and even Redon. Perhaps because a number of the greatest advanced artists of nineteenth-century France *did* exhibit at the Salon, it is no accident that many of this museum's Salon paintings are by these artists, whose works were collected by Chicagoans with a highly developed taste for avant-garde art.

The Art Institute's first major bequest, the Henry Field Collection of French paintings, given in 1894 on the occasion of the opening of the museum at its present location, included works by artists whose careers were determined by their success at the Salon. Rousseau's Barbizon landscape *Springtime* (p. 36), Millet's unorthodox *In the Auvergne* (p. 86), and the beloved *Song of the Lark* (p. 109) by Jules Breton came to the Art Institute as part of this gift.

Another great Art Institute patron, Mrs. Potter Palmer, is renowned among American art collectors for her virtual discovery of Monet, Renoir, Pissarro, and Degas. She had a very good sense of the history of advanced French art and, in addition to the Impressionist works she favored, her vast collection included important paintings by three mid-century artists much admired by her heroes — Delacroix's *Lion Hunt* (p. 32), Corot's *Interrupted Reading* (p. 95), and Millet's *Bringing Home the Newborn Calf* (p. 50), which she gave to the Art Institute, along with works by Salon artists Jean Charles Cazin (p. 110) and Pascal Dagnan-Bouveret (p. 111) that are reproduced in this volume.

Martin Ryerson and Mrs. Lewis Larned Coburn, who each amassed a large and important group of Impressionist paintings during the late nineteenth and early twentieth centuries, also bought from the Salons and from artists who made their reputations there. The superb early Corot, *View of Genoa* (p. 24), and *The Fisherman's Family* (p. 115) by Pierre Puvis de Chavannes were owned by Mr. Ryerson and Pissarro's great Salon landscape of 1866, *The Banks of the Marne in Winter* (p. 79), came to the Art Institute through the generosity of Mrs. Coburn.

George F. Harding — known for a collection of arms and armor that he assembled after the First World War and housed in a custom-built castle on Chicago's south side — also purchased paintings of

nudes, military subjects, and classical spectacles. Among them, Jules Joseph Lefebvre's *Odalisque* (p. 100) and Jean Léon Gérôme's *Chariot Race* (p. 101) are perfect embodiments of French Salon art produced in the last decades of the nineteenth century. They came to the Art Institute, with his arms and armor collection, in 1982. During the past two decades, a revival of interest in such less well-known nineteenth-century Salon artists as Louis Léopold Boilly, Frédéric Bazille, Paul Camille Guigou, and Gustave Moreau has stimulated serious study and appreciation of their art. Examples of their work in the Art Institute's collection have been acquired by purchase, enabling a presentation of a broader and more accurate history of French painting in the nineteenth century.

Indeed, Salon art (or Salon-dominated art) in The Art Institute of Chicago is of such diversity and importance that one can learn a great deal about the politically and artistically tumultuous nineteenth century from studying the collection. This kind of claim may not seem exceptional to today's Art Institute visitors, but it might have shocked the museum's early patrons, whose gifts form the core of our famous Impressionist and Post-Impressionist collection. Given their predilection for the avant-garde, they would be dismayed at our inclusion in this book of paintings by Gérôme, Lefebvre, and Dagnan-Bouveret as meritorious works from a museum known for its fervent devotion to rebel artists, many of whom despised or ignored the Salon. However, the Art Institute owns a most interesting range of works created for the Salon, and this publication is designed to redress the imbalance in the public's view of our collection by giving weight to "official" art, just as we do to the rebel art that enchanted the museum's founders and continues to be admired today.

Richard R. Brettell
Searle Curator of European Painting
The Art Institute of Chicago

French Salon Artists
1800-1900

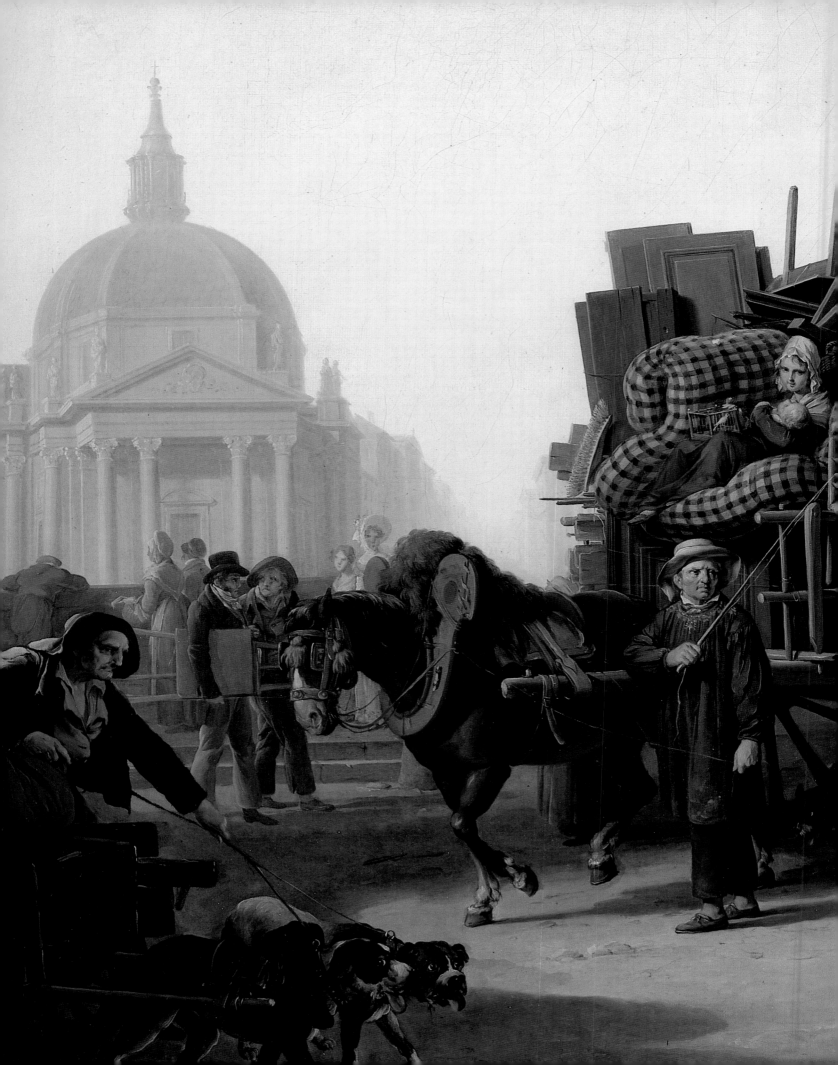

BOILLY'S SCENES OF MODERN LIFE

In the early decades of the nineteenth century in France, when French painters dedicated themselves to literary and historical themes, Louis Léopold Boilly was among the first major artists to make a successful living representing modern daily life. His oeuvre, in all media, combined images of shopkeepers, provincial aristocrats, industrialists, and various street people interacting in a kind of social dance. He produced exquisite, small paintings with quasi-erotic subjects, as well as larger Salon paintings, many of which deal directly with the urban, political realities of his age.

The Arcades at the Palais Royal is a large, finished drawing made in preparation for a painting sent by Boilly to the Salon of 1804. Its subject is a group of twenty-four figures gathered on a warm summer day under the arches of the Palais Royal (then called the Palais du Tribunat), where government offices were housed. Most of the female figures are prostitutes, whose admirers stand in their midst to flirt and negotiate with them. The man on the left is selling dogs, whose explicitly sexual activities Boilly censored from his final painting for the Salon.

What is surprising about Boilly's work throughout his career is the extent to which it confronts urban life with the cool aesthetic detachment of Neoclassical style and composition. Even after French painting had been swayed by the winds of Romanticism, Boilly continued to compose each composition with tight, geometrical order and to create an almost mirrorlike, uniform surface. *The Movings,* painted nearly twenty years after *Arcades,* is a complex and socially serious work of art. Submitted to the Salon of 1822, the painting represents several families moving their households or possessions through the streets of Paris. The supporting cast of figures includes people of every age and social class. A fashionably dressed woman is out for a daytime stroll; an artist, easel and portfolio under his arm, is accosted by a beggar; a band of mourners, dressed in black, walks slowly behind a horse-drawn hearse. The street scene is further activated by animal life – five dogs, two horses, and a cat – placed strategically throughout the picture.

The tension created by this drama is expressed by the contradictory nature of the setting. To the right is a group of houses, built in the seventeenth and eighteenth centuries, that lined the Wheat Port on the right bank of the Seine, directly across from the Ile Saint Louis. However, in Boilly's composition, the houses face the church of Santa Maria de' Miracoli on the Piazza del Popolo in Rome! Why did the painter deliberately choose to create a setting in two completely different cities? The answer takes us to the center of the painting's meaning.

In *The Movings,* most of the figures are traveling away from the Roman setting toward the anonymous apartments of Paris. However, the most poignant group in the painting, the owners of the principal wagon with its gaily decorated horse, moves toward the golden, tinted image of the church in Rome. This humble couple, with their infant child and caged songbird, seem to have come from the provinces dressed in their regional finery to make their fortune in Paris. Perhaps the fact that they, just as the hearse, travel toward the left of the composition, with its distant, miragelike setting, is a subtle allusion to the futility of their efforts and plans. The entire ensemble of figures, possessions, and animals has been caught by Boilly in a moment of transition – between life in the city and the country, between Rome and Paris, between dreams and reality, and, ultimately, between life and death.

Detail of
The Movings

Louis Léopold Boilly
The Arcades at the Palais Royal
1803-04

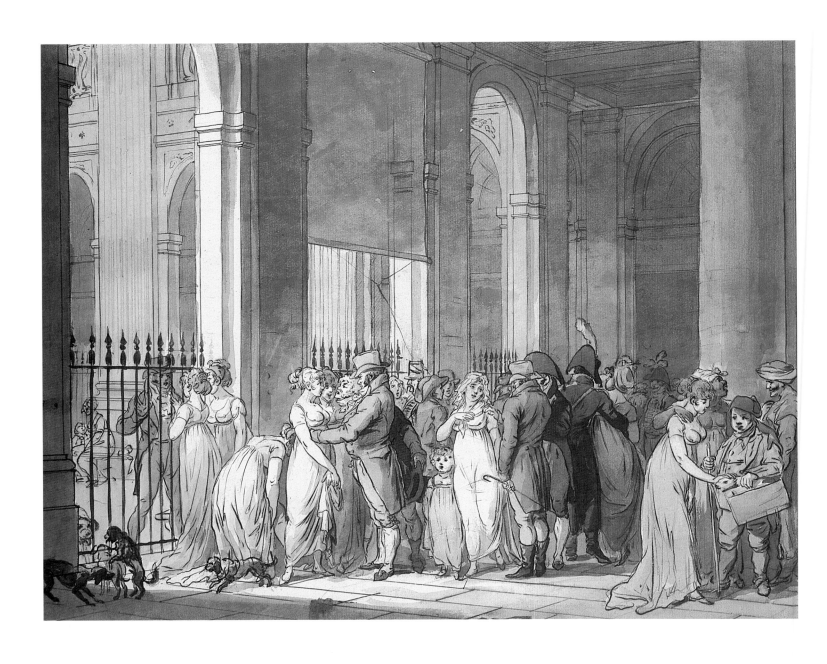

Louis Léopold Boilly
The Movings
1822

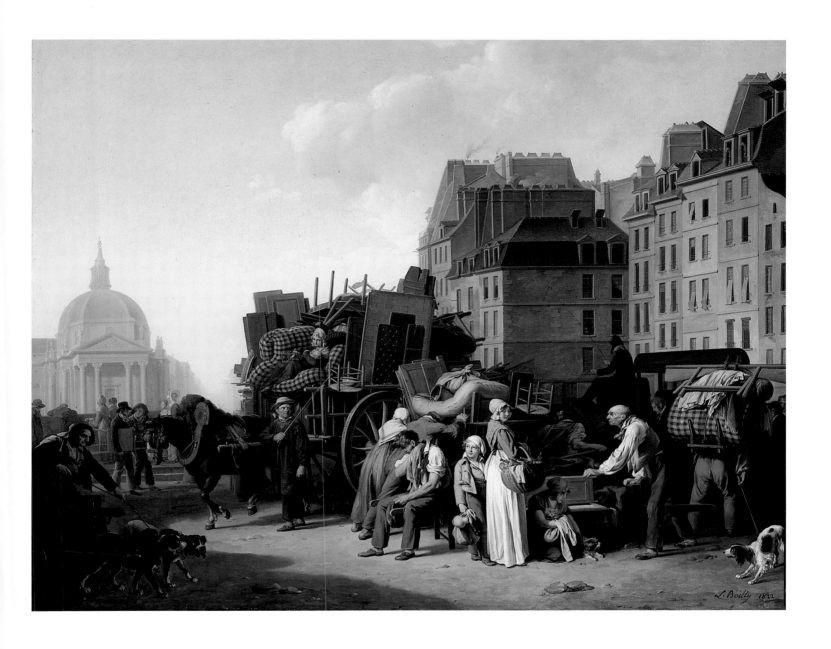

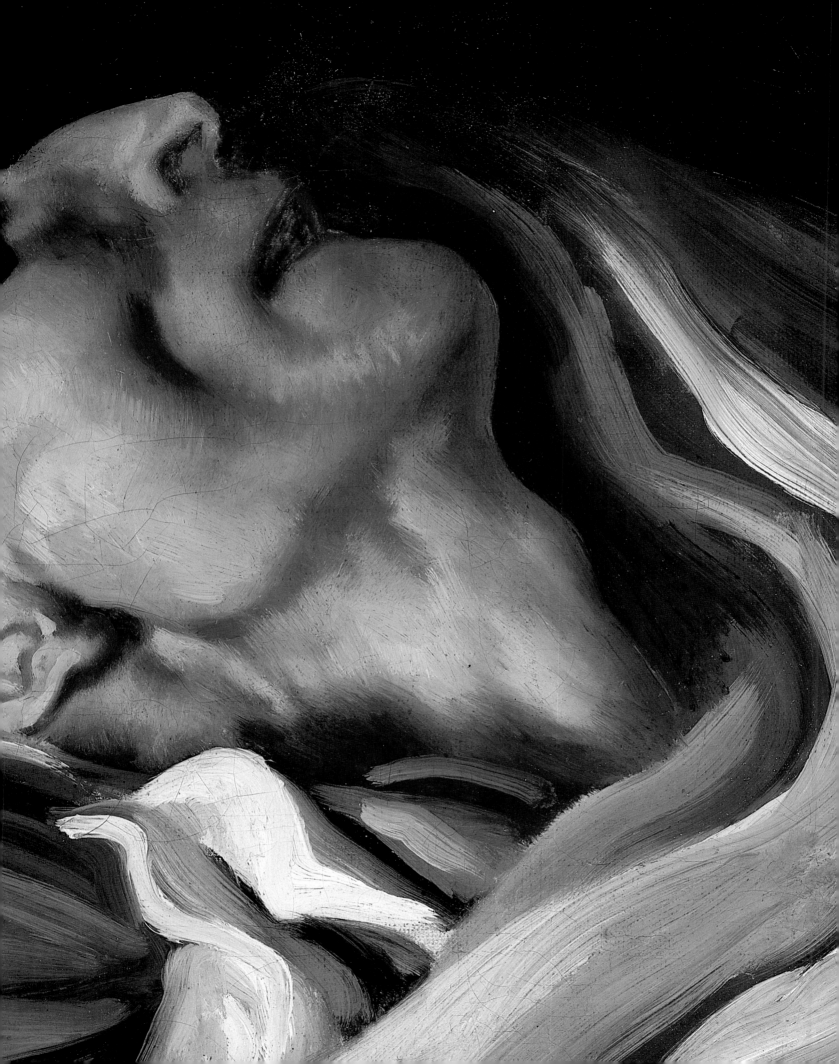

GERICAULT'S CONTEMPORARY DRAMAS

The turbulent political and human realities brought about by Napoleon's exile and the Bourbon Restoration changed forever the heroic ideals expressed by eighteenth-century Neoclassicism and the Enlightenment. Although schooled in these ideals, Théodore Géricault found himself in the midst of a disillusioned generation and, rather than glorify human action, sought to dramatize its dark and irrational forces. His major achievement, exhibited at the Salon of 1819, was *The Raft of the Medusa*, now in the Musée du Louvre, Paris. This ambitious painting represents neither a scene from literature nor a great moment in history, but a ghoulish event of contemporary history involving accusations of cannibalism, which had occurred in 1816 and had been extensively reported in the international press. Géricault depicted this horrific incident in truly epic proportions, and the painting was, perhaps, the first major "succès de scandale" in the nineteenth-century Salon.

Much has been written about Géricault's preparation for that masterpiece. His trips to morgues and hospitals, where he drew and painted cadavers and severed body parts, figure prominently in the history of the modern artist's concern to capture reality in its essence. *After Death,* a graphic and chilling depiction of lifelessness executed with creamy, intense brushwork, has often been published as an exemplar of Géricault's methods. In fact, the artist's name has been attached to the painting since it first appeared on the market at the end of the nineteenth century. Interestingly, a recent cleaning revealed not Géricault's signature, but that of his little-known friend and painting companion Charles Emile Champmartin. Champmartin, who was also a lifelong friend of the great French Romantic painter Eugène Delacroix, accompanied Géricault on his occasional visits to the dissecting rooms of Parisian hospitals. The younger artist, in fact, prepared a painting entitled *The Dead Christ* for the same Salon in which Géricault exhibited *The Raft of the Medusa*. Unfortunately, no print or photograph of Champmartin's Salon entry survives, but, from the evidence of this study alone, Champmartin's qualities as a painter were great enough to have fooled more than three generations of art historians.

The Art Institute possesses a number of drawings and compositional studies executed by Géricault that reveal his interest in compelling, documentary detail. The sheet reproduced here, predating by several years his Salon masterpiece, was one of a group of studies the artist may have been considering for use in a larger work, never undertaken, of battle. During the years of Napoleon's glorious military triumphs, hundreds of aspiring artists struggled to gain official commissions by painting large battle scenes. Yet, Géricault, in this field, as in history painting, did not follow tradition. His sketches stress the dramatic intensity of combat itself rather than the particular qualities of a specific battle. We see no uniforms; there are no lines drawn between the two opposing sides. All is action and energy, quickly seized by the artist's pen and brush as he captured life-giving substance of moving forms. It is perhaps unfortunate, given the ambition of these studies and their historical resonance with the art of Leonardo da Vinci and Peter Paul Rubens, that the young Géricault never brought them to the full-blown scale of a Salon painting. Indeed, because of his early death at age thirty-three, it was not until his younger friend Delacroix took up this genre that monumental battle painting was created that lived up to the promise of these slight studies.

Detail of
After Death,
Study of a
Severed Head

Théodore Géricault
Sketches for a Cavalry Battle, Mounted Officer
c. 1813/14

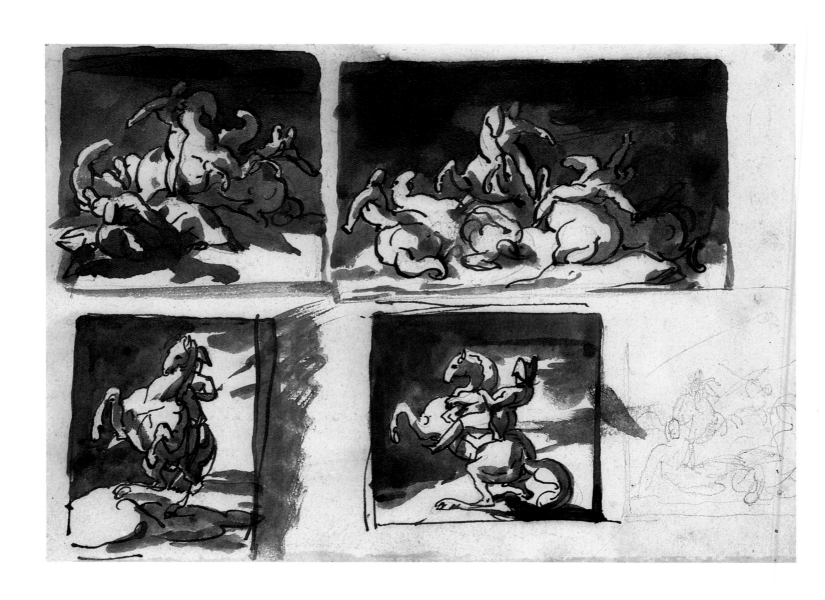

Charles Emile Champmartin
After Death, Study of a Severed Head
c. 1818/19

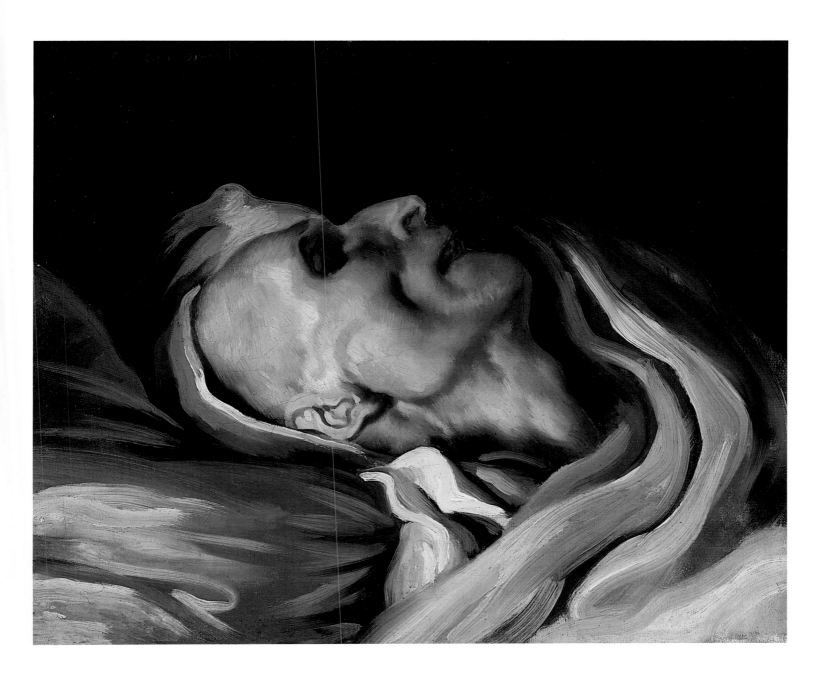

Eugène Delacroix
Combat Between the Giaour and Hassan in a Ravine
1826

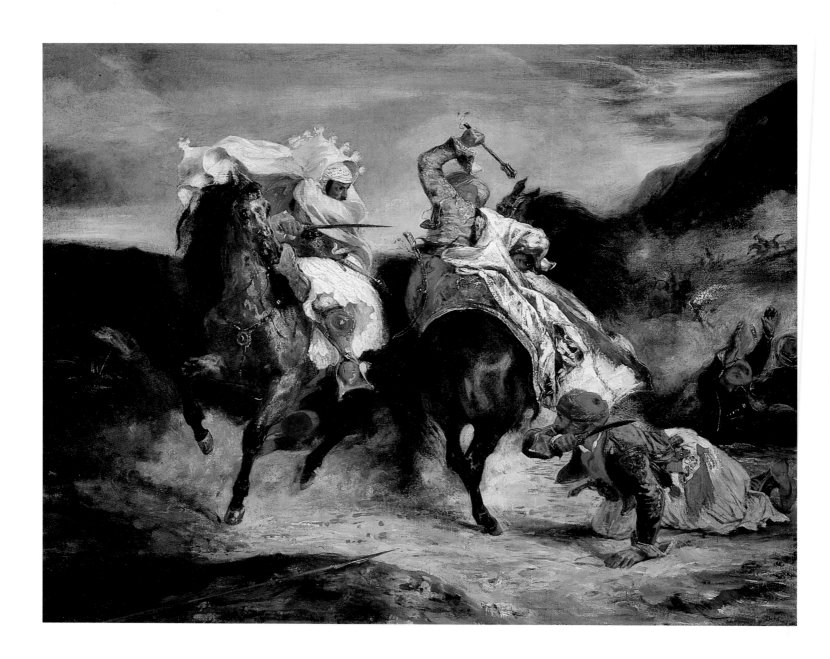

At odds with established social and aesthetic traditions, Romantic artists, poets, and composers, who flourished during the first half of the nineteenth century, explored realms of passion and imagination often inspired by nature or faraway, exotic lands. With his early Salon entries in 1822 and 1824, Eugène Delacroix soon became one of the undisputed leaders of Romanticism in France.

Finished in the spring of 1826, *Combat Between the Giaour and Hassan* was included in an exhibition arranged at the Galerie Lebrun in Paris as a benefit for the Greeks in their war of liberation against the Turks (1824-32), a struggle that had totally captured the Romantic imagination. Delacroix lingered over the painting, correcting certain passages and improving color contrasts, and submitted it several weeks late. The work clearly benefitted from the painter's attentions, for it is among his earliest and most brilliant representations of combat.

The painting reminds us not only of the artist's fascination with Greece, but also of his anglophilia. Delacroix had just visited England in 1825 and had come away with a newly strengthened admiration for its most famous Romantic poet, Lord Byron, who had gone to Greece to join the battle for liberation. It was to a lengthy poem by Byron that Delacroix turned for the subject of this painting. The poem, called "The Giaour," was first published in English in 1813 and translated into French in 1824. However, there is little about the painting to suggest that Delacroix actually read the poem; several modern scholars prefer to think that he read critical commentaries on the poet, rather than the poetry itself.

In Byron's passionate text, a particular Christian infidel of a type known as the Giaour and a Turk whom Byron called Hassan meet in a crowded battlefield alive with the hissing of gunshots. There, the Giaour avenges his lover's death at the hands of Hassan. In the painting, Delacroix minimized the setting to concentrate on the two figures. Clad in pure white, the Giaour with a black beard and bloodshot eyes is about to kill Hassan, whose face – and, hence, character – is invisible to us. The two are seen in exactly mirrored positions at the moment before the Giaour administers his fatal blow. What was, for Byron, "the last embrace of foes" becomes, for Delacroix, a dance of death, passionately expressed in sweeps of rich, deep color and freely handled paint.

There is evidence to suggest that Delacroix submitted his *Combat Between the Giaour and Hassan* to the Salon of 1827, and that the painting was rejected. Since nine other of his paintings were accepted for exhibition, it is possible that the negative response to this canvas was the result of the artist having entered so many works that year.

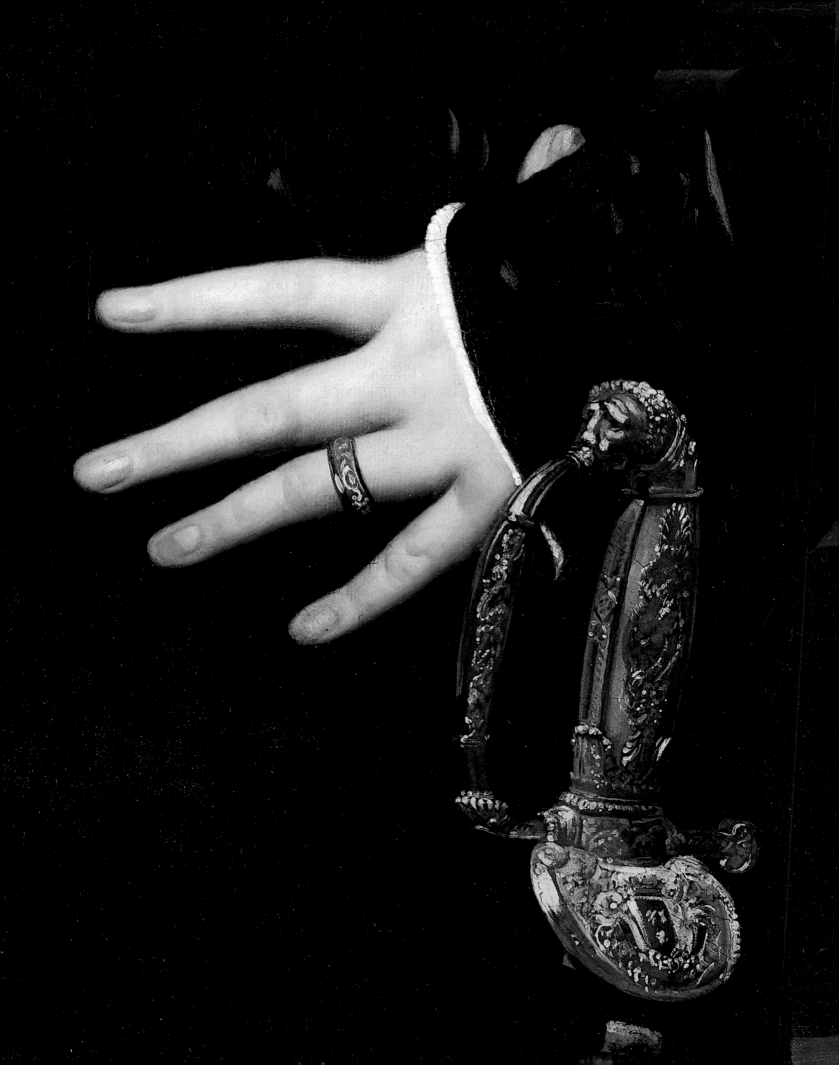

INGRES'S PORTRAITURE

Two painters dominated French art during much of the first half of the nineteenth century – Eugène Delacroix and Jean Auguste Dominique Ingres. Delacroix's fascination with the representation of powerful human emotions, scenes from Romantic literature, and life in the Near East was countered by Ingres's devotion to the measured, rational values of classical civilization as they had evolved from ancient times and the high Renaissance to the aristocratic classical culture of seventeenth-century France. A pupil of the great Neoclassicist Jacques Louis David, Ingres aimed to be a painter of eternal civilized values and to render ideas of order immutable through art. Throughout his life, he battled against what he felt to be the "chaotic" Romanticism of Delacroix and his followers and the growing realism of the artists of the Barbizon School, who painted natural rather than idealized landscapes. Ingres enjoyed tremendous fame during the years he exhibited at the Salon, and an entire gallery was devoted to a large retrospective of his work at the 1855 Universal Exposition.

Since Ingres considered himself a history painter, it is almost ironic that he actually made his living doing portraits, in both pencil and oil, and that many of his greatest successes at the Salon were his portraits – now considered to be the best work of his career.

The superb graphite portrait of the civil engineer Charles François Mallet was made while Ingres was living in Rome. In the Eternal City, he supported himself by doing carefully conceived pencil drawings of English and French tourists and expatriots. Mallet's portrait is among the most ambitious of these. Rather than representing the French engineer in a conventional and modest three-quarter pose, Ingres created an exquisitely drawn, almost mock heroic portrait of a full-scale figure in miniature. Precisely delineated with Ingres's perfect pencil line, Mallet dominates his setting, which is no mere backdrop, but a powerfully receding view of the Tiber River with the Ponte Fabrizio in the background. Surely, it is no accident that a cityscape with a bridge figures so prominently in the portrait of a man who made his reputation as a bridge designer.

While the majority of Ingres's portrait clients were bourgeois like Mallet, the artist also received commissions from aristrocrats. The portrait of the Marquis of Pastoret, exhibited at the Salon of 1827, is among the strongest of the artist's representations of this social class, whose position in nineteenth-century France was scarcely secure. The portrait was probably begun in 1823, the year that the thirty-two-year-old count seems to have helped the artist become a full member of the French Academy. The refined line of Pastoret's dashing silhouette, the deep, rich green of the fabric wallcovering, and the pose – at once alert and relaxed – brilliantly reveal the effete and indulged character of this young aristocrat; Ingres's sensitive, yet almost imperceptible, brushwork brings him to life. For the face, Ingres used small, soft strokes of paint, each of which he carefully blended. Yet, to represent the sword and metal, he purposely executed a network of separate lines and dots of paint, allowing each to dry before adding the next. Ingres took at least three years to complete the portrait, which gave him time to include the Legion of Honor medal that the count received in 1824. Edgar Degas, who admired Ingres's elegant mannerisms and who succeeded him as the greatest French portrait painter of his own generation, bought *The Marquis of Pastoret* in 1897 to complete his own large collection of Ingres's paintings and drawings.

Detail of
*Amédée-David,
The Marquis of
Pastoret*

Jean Auguste Dominique Ingres
Portrait of Charles François Mallet
1809

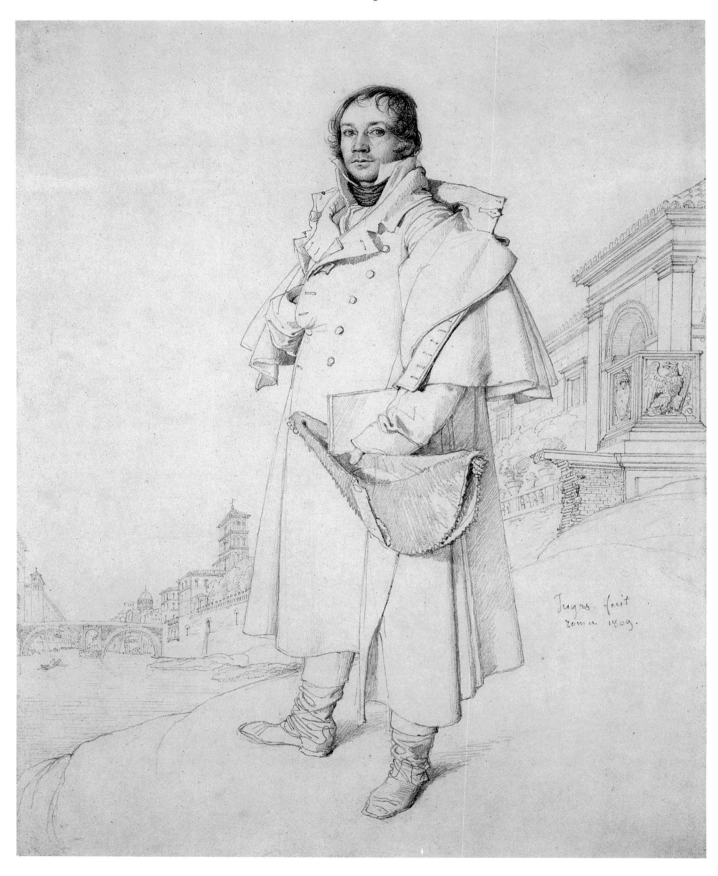

Jean Auguste Dominique Ingres
Amédée-David, The Marquis of Pastoret
1823-26

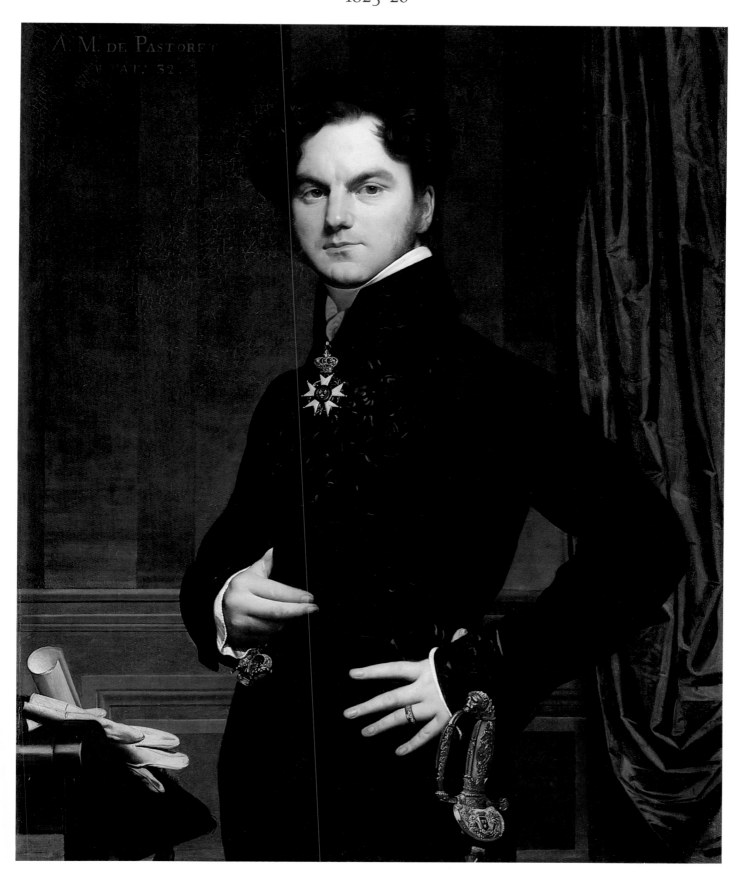

Jean Baptiste Camille Corot
View of Genoa
1834

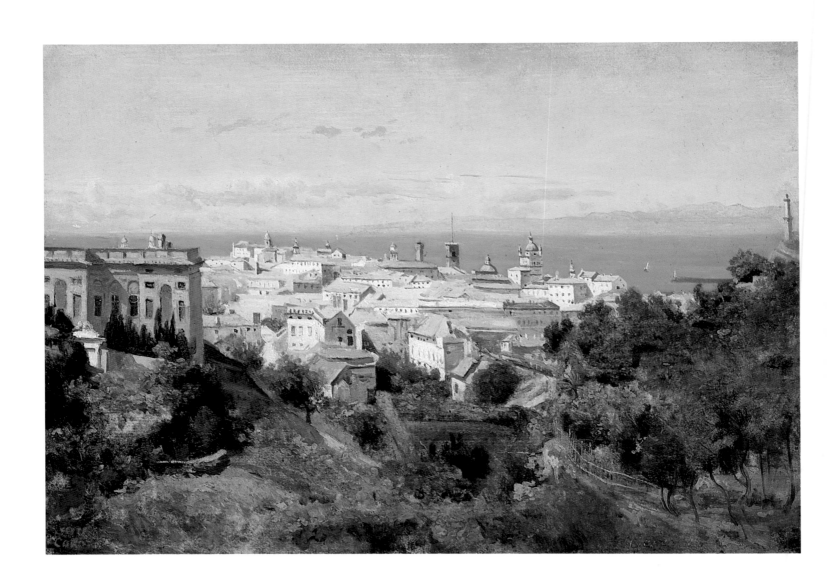

Corot was one of many French Salon artists to visit Italy. But, unlike most other academic artists who traveled to Rome, he was not preoccupied with the art in churches, museums, and palaces. Rather, Corot spent his time in the Italian countryside doing oil sketches. Returning to France after his first trip in 1826-27, he created large-scale canvases for the Salon, often including religious and mythological figures set in Italian landscapes based on those he studied throughout Italy.

Made during the artist's second trip to Italy, in 1834, *View of Genoa* was not created for public exhibition. It belongs to the eighteenth- and early nineteenth-century academic landscape tradition of the oil sketch done directly from nature in order to educate the artist's hand and eye and, occasionally, to refer to in developing a studio-composed landscape for exhibition. Corot borrowed this technique of *plein-air* oil sketching from the practice of the great Neoclassical landscape painter Pierre Henri de Valenciennes and his students Achille Michallon and Jean Victor Bertin. Each of these artists painted out of doors in order to study directly all the subtle nuances of nature. In this way, they anticipated the *plein-air* aesthetics of the Impressionists, several of whom would paint with the elderly Corot.

To fully capture his subject, Corot walked up the undeveloped hillside above the Spianatta dell'Acquasola, a large public park created in the 1820s. He set the urban mass of Genoa in the center of his composition, defining the left edge with architecture and the right edge with an expanse of sea and sky. Genoa itself appears as a geometric arrangement of walls, roofs, and windows surmounted by church towers, none of which is allowed to be dominant. Behind the city, the vast, blue expanse of the Mediterranean spreads lazily toward the horizon with its gentle skiffs of clouds. Only one small sailboat is visible. It is as if Corot intentionally shielded the viewer from the knowledge that Genoa was the largest commercial port on the west coast of Italy. All is silent and deserted in this eternal, sunny realm.

Like most works of this type, *View of Genoa* was painted on paper and later selected by the artist to be mounted on canvas for easier framing and viewing. Along with most of the oil sketches painted by Corot, it came to light only after Corot's death in 1876 at the sale of the contents of his studio. At that time, many private collectors, as well as the young Impressionist painters, were given their first chance to see this aspect of Corot's work, which had remained all but unknown during his lifetime.

Gustave Courbet
Seated Model Reading in a Studio
c. 1853

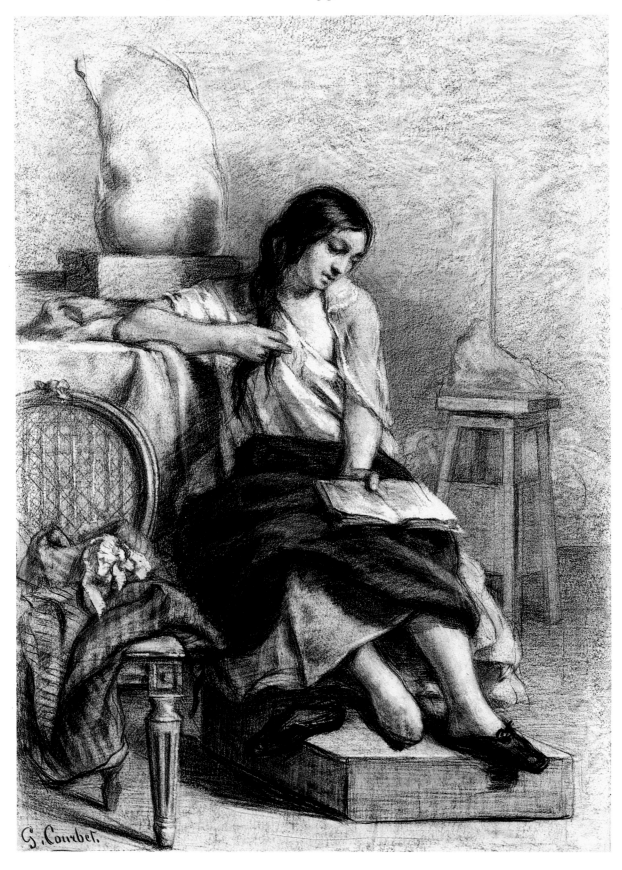

Although Gustave Courbet's naturalistic painting of rural life, *After Dinner at Ornans*, now in the Musée des Beaux-Arts, Lille, was warmly received at the "Republican" Salon of 1849, his later, large canvases of commonplace and occasionally coarse people irrevocably separated him from both Neoclassicism and Romanticism, as well as other hybrid Salon styles. Courbet was the undisputed leader of Realism and he profoundly influenced the next generation of artists.

Courbet did very few finished drawings of the quality of the sheet reproduced here. Signed but not dated, it was probably made for sale or exhibition, as its large size and carefully worked surface suggest. However, Courbet only once sent drawings to a Salon, that of 1848, and this sheet does not correspond to the titles of any of the four accepted for that exhibition. The superbly controlled and variably worked surface, moreover, relates it more closely to drawings the artist executed in the first half of the 1850s.

As with so many other works by Courbet from this period, *Seated Model* is a "real allegory," a symbolic evocation of the arts using actual elements of the studio portrayed in as realistic a manner as possible. We accept the model as a real person sitting in a real studio. One wants to identify the studio as Courbet's own, but on closer inspection, it seems to be that of a sculptor rather than a painter; a clay *modello* sits on a stand in the rear of the room, covered with cloth to keep it moist. The model's pose and her ambiguous relationship to the plaster cast of a famous classical sculpture, *Crouching Aphrodite*, on the table behind her force the viewer to think about the manifold relationships between art and life. Courbet seems to have intentionally contrasted her with this torso, its arms broken and its body turned from our gaze. At first glance, she appears to be a reader-muse, her clothing discarded on a chair. One slipper on and the other off, playing listlessly with her hair, she is neither dressed nor nude, neither reading nor musing.

Courbet made various paintings and drawings of reading and sleeping women during the late 1840s and early 1850s, such as a sheet in the Musée du Louvre, Paris, dated 1849, showing a clothed woman who has fallen asleep while reading. Yet, the Chicago drawing is more complex than any of these, expressively and tenderly alluding to the relationships between looking and reading, sculpture and painting, dreams and reality.

Jean Léon Gérôme
Portrait of a Lady
1851

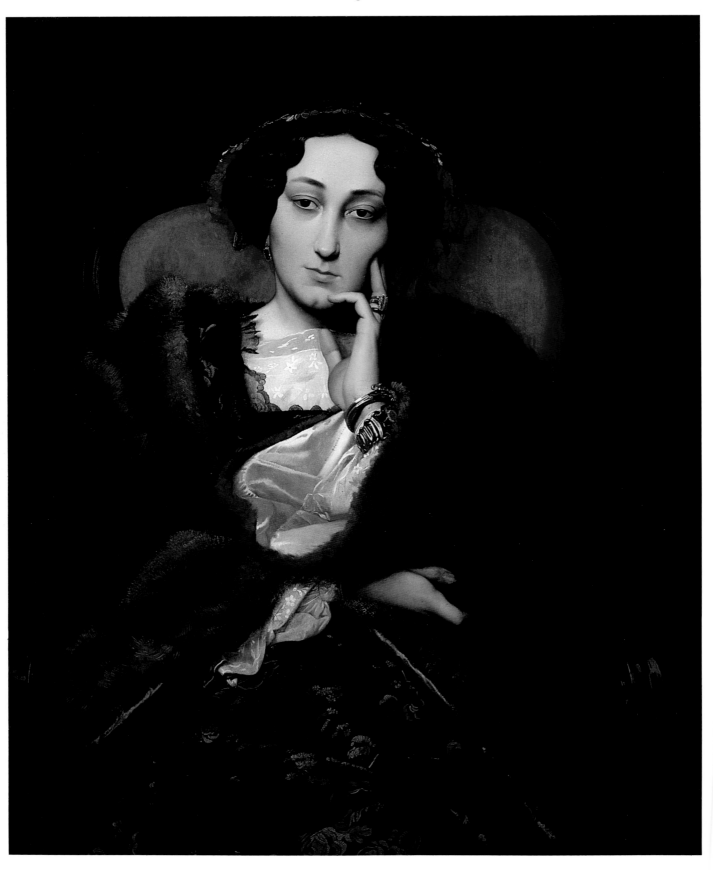

Had Gérôme died young, as did Géricault, he would be known today as a promising, even brilliant, Salon painter and minor portrait painter in the manner of Ingres. However, he lived to become the most successful Salon history painter of the second half of the nineteenth century, when the aesthetic winds began to blow in quite a different direction from his own, and, thus, he also became the man most reviled by the Impressionists and their followers. Along with William Adolphe Bouguereau, Gérôme was the enemy of what was called "The New Painting," indeed, of all we have been taught to love in French painting after 1860.

Unfortunately, we know almost nothing about Gérôme's portraits. He, himself, neglected them, refusing ever to exhibit them or to include photographs of them in albums devoted to his work. Even the subject of this portrait remains unidentified in spite of the efforts of the most assiduous student of Gérôme's oeuvre, Gerald Ackerman. However, the portrait itself provides clues.

Although the presence of a ring on the woman's finger implies the sitter is married, the ring itself does not accord well with contemporary French wedding rings, which tended more often than not to be simple. There are also certain oddities about the costume to suggest that the subject might be an actress or member of the demimonde rather than a respectable married lady. The woman, superbly dressed and jeweled, can scarcely be called beautiful. Yet, the painter has so carefully analyzed the orbs of her eyes, the undulating topography of her dimpled chin, and the snakelike curves of her hair, and has so obsessively described the satin, velvet, lace, and fur of her clothing, that we soon attribute the beauty of the painting to the sitter.

In the lack of specific setting and in Gérôme's characteristically precise brushwork, the painting is like a photographic portrait of the period, allowing pose, gesture, and costume to carry all its meaning. Although he certainly succeeded in making her seem vacant, it would be unfair to say that Gérôme was critical of his sitter. We know enough about portrait painting of this time to say that, although a portrait can speak volumes, it may also speak more fiction than fact. This work might very well be an uncommissioned portrait of an actress or model that Gérôme made as an exercise in the manner of Ingres in order to attract clients.

Gustave Courbet
Mère Gregoire
1855 and 1857-59

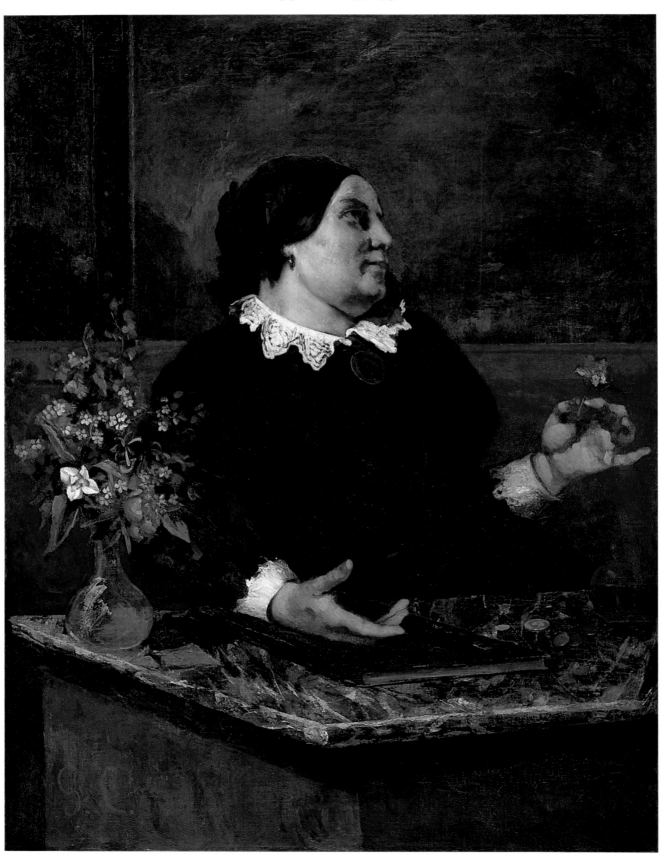

Mère Gregoire was first exhibited in the great private exhibition of Courbet's work held in conjunction with the International Exhibition of 1867 in Paris. Courbet himself supervised both the selection and the hanging of his pavilion, located on the Place d'Alma near the fairgrounds; and in his catalogue, he supplied the painting's title and date.

The subject of the painting, Mère Gregoire, is a character in a popular song written in the 1820 by the French lyricist Pierre Jean Béranger. Béranger was a poet of the people; his politics were anti-establishment and his songs were often ribald. Mère Gregoire, as described by Béranger, was the amply proportioned proprietor of a café who favored certain clients with her charms and those of other women in her employ. In choosing to depict Mère Gregoire, Courbet aligned himself with this older revolutionary poet whose arena was the cafés, where drinking often led to loose, unconstrained conversation critical of established political, social, and aesthetic values.

Courbet most probably started the painting in 1855, as he later indicated in his exhibition catalogue. However, at that time, he painted only the head on a small horizontal canvas. The great writer and critic Théophile Gautier saw this work in Courbet's studio in 1856 and described it then as Mère Gregoire. By 1859, when it was viewed again in Courbet's studio by fellow artist Zachary Astruc, the painting had been enlarged to its present dimensions and transformed from a small-scale depiction of a fictional character to an elaborate genre scene. It is possible that this enlargement was begun in 1857, the year of Béranger's death and of a popular reassessment of his career.

Courbet represented the madam behind her counter in the midst of a negotiation with an unseen client, who presumably stands to her left. With one hand, she offers forth a tricolored flower, a symbol of love and possibly an allusion to her Republican politics. Her other hand, openly expectant, rests on the ledger near a beautifully painted still life of coins. Clearly, she will "sell" her "flower" for money, note the transaction in her ledger, and then ring the small bell to the far right to summon a particular female companion.

This representation of a portly madam is a respectful one. The lyrics of the song from which it was derived are a good deal more explicit than Courbet's painting. In the end, the artist monumentalized, indeed maternalized, the kind of sexual transaction he portrayed.

Eugène Delacroix
The Lion Hunt
1861

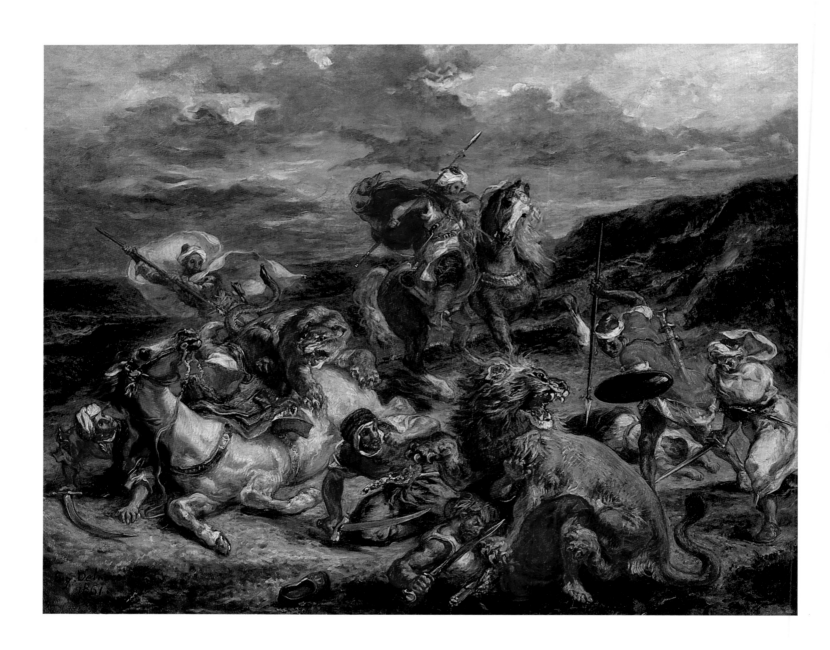

Delacroix was preoccupied with the subject of the lion hunt throughout the period 1854-61, and the Art Institute's superb painting is one of his five surviving canvases of this subject. As is often the case with Delacroix, his ultimate source for this subject was the art of the seventeenth-century Flemish artist Peter Paul Rubens, whose greatest representation of the lion hunt, at the Alte Pinakothek, Munich, was known to Delacroix only from engravings. The example of Rubens, however, was not the painter's only inspiration; a book by a French army lieutenant, Jules Gérard, entitled *Lion Hunts and Other Hunts in Algeria,* published in 1854, was Delacroix's immediate impetus to paint the subject.

We know that Delacroix drew and painted lions from nature, most often in the safe confines of the Paris zoo. In his first canvas, of 1854-55, the brilliance of Gérard's descriptions blended in the artist's mind with the ferocious painterly exaggerations of Rubens to produce a monumental Romantic painting. Delacroix sent it to the Universal Exposition of 1855 in Paris, where he was honored with an entire room, as was his rival, the classicizing painter Ingres. Delacroix considered the *Lion Hunt* his signature painting, and it is unfortunate that this large version of the composition was badly damaged by fire in 1870, and exists today in the Musée des Beaux-Arts in Bordeaux as a massive and heroic ruin.

In the four smaller versions, most probably executed for sale, Delacroix altered the composition each time to suit his mood and the dimensions of the chosen canvas. Possibly made on commission from the Count of Aguila in 1861, the Art Institute painting was the last to be completed. Its first public appearance, along with other works by the artist, was in 1868, when the count held a sale. In the Chicago painting, Delacroix moved the hunt from the foreground, where it must have seemed to thrust out at viewers of the large 1855 canvas, into the middle distance, where its swirling drama is somewhat removed from the viewer's space. Here, Delacroix concentrated his attention on subtle distinctions of color and formal balance, and, despite his loosely gestural brushwork and brilliant palette, the whole painting takes on the effect of a cabinet picture. As seen here, the lion hunt is less a fierce combat of survival between man and beast than an exemplar of Romantic imagery and technique for the collection of an aristocrat.

Interestingly, the painting was enlarged on all four sides by as much as an inch after its sale to the count and before being acquired by the great Chicago collector Bertha Palmer in 1893. This enlargement was perhaps done to make the composition even less intense and, hence, safer.

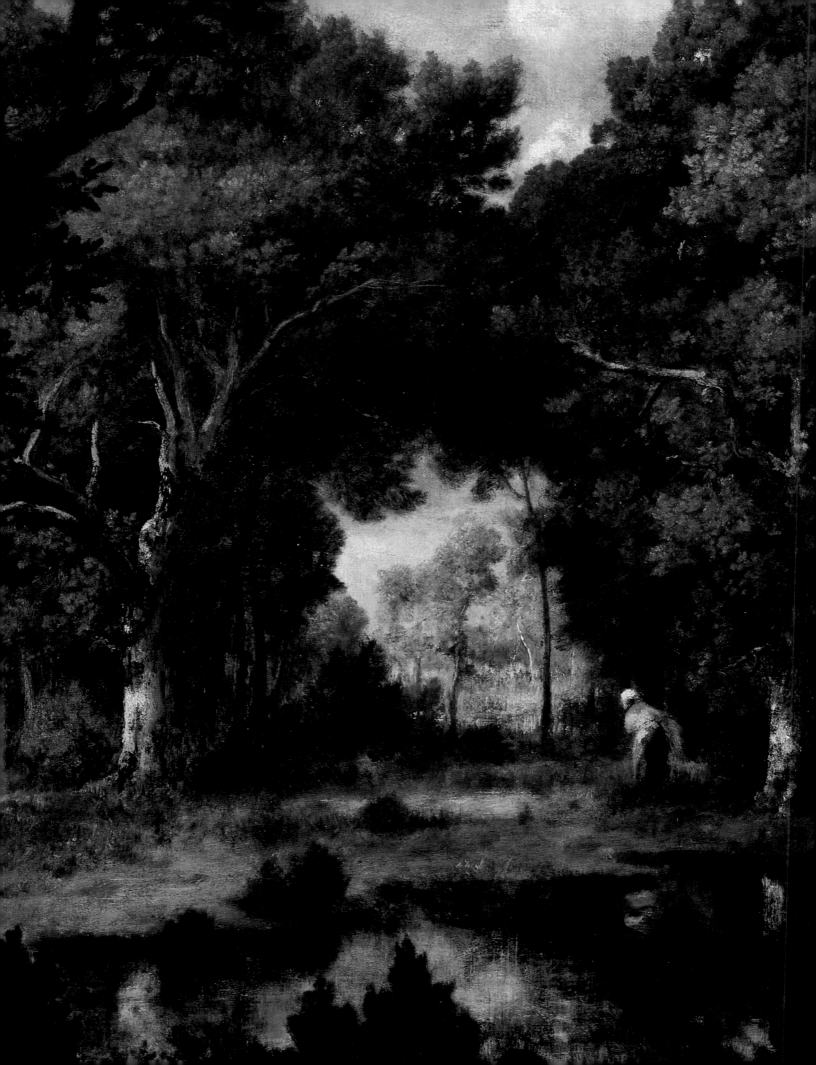

BARBIZON LANDSCAPE PAINTERS

With the Salon of 1848, the Barbizon School of painters, named for a small village at the edge of the Forest of Fontainebleau where many of the artists lived and worked, became a definite, recognized entity, dominating French landscape painting until the late 1860s. However, throughout the 1830s, both Théodore Rousseau and Narcisse Virgile Diaz de la Peña had trouble being accepted by Salon juries. This rejection resulted from two strong prejudices: the first was against landscape painting itself, which most academicians considered a minor genre; and the second was against seemingly uncomposed or "real" landscape paintings of actual French sites. Preference was given to Italian views, most of which were executed in the studio to conform to academic standards of composition and finish. However, by the end of the 1840s, paintings of the French landscape had already begun to play a visible role in the Salon, and most of the major artists of the Barbizon School earned Salon medals; by the 1860s, many had gained international reputations and their work was being bought by French as well as English and American collectors.

The landscape of the primeval forest was the stock-in-trade of Rousseau, Diaz de la Peña, Dupré, and, occasionally, Corot. Most of the painters worked on the outskirts of the famous Forest of Fontainebleau itself, exploring sites within easy walking distance of the small villages that were clustered along the north and west edges of the immense royal domain. Many of their landscapes explore light that sifts through and flickers over foliage. In some examples, like Rousseau's *Springtime,* we are outside the forest, looking at light as it falls over trees and water and makes the lush foliage palpable. In others, like *Pond in the Woods* by Diaz de la Peña, we stand under great, soaring trees, looking through the gnarled branches to a pool and, finally, into the light-struck field in the distance. In both paintings, one senses the wetness and variability of the atmosphere.

In these, as in most landscapes of the Barbizon School, there is a subtle expression of pantheism. Virtually all the landscapes are centered on a light-filled clearing or a reflective pool in the forest, giving a focus, a sense of place, to these virtually unpeopled, natural worlds. The painters also paid a great deal of attention to the sky, and the low horizon lines and brilliantly composed clouds remind us that the heavens were considered the unifying force in landscape and that light was oftentimes equated with God in Romantic texts of the period. Thus, most landscape painters of the Barbizon School considered their work to be profoundly moral in character. For them, nature was the opposite of the city and its crowding, corruption, and moral degradation. Before their landscapes of silence and solitude, one could be alone with oneself and one's thoughts, far from the pressures and evils of civilization.

Like most paintings of the Barbizon School, these two landscapes are carefully structured to conform to certain definite rules of compositional balance and shading. The eye moves easily back into the picture space through layered arrangements of light and dark, near and far. Yet, in spite of this conservatism and the clear relationships between Barbizon landscape paintings and those by Jacob van Ruisdael, Meindert Hobbema, and other seventeenth-century painters of northern Europe, the fact that these compositions included peasant figures and made no reference to either modern or aristocratic civilization gave them an anti-academic, almost anti-establishment meaning during the 1830s and '40s.

Théodore Rousseau
Springtime
c. 1860

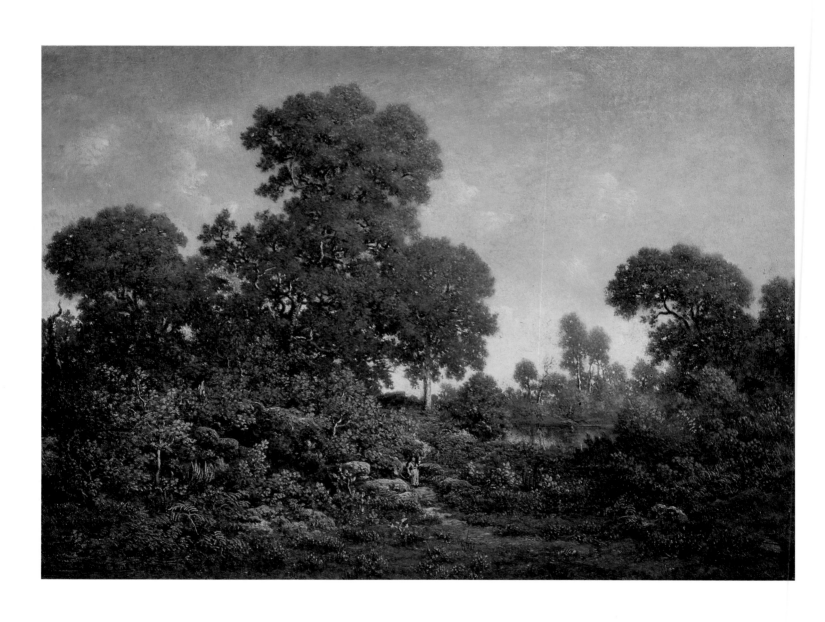

Narcisse Virgile Diaz de la Peña
Pond in the Woods
1862

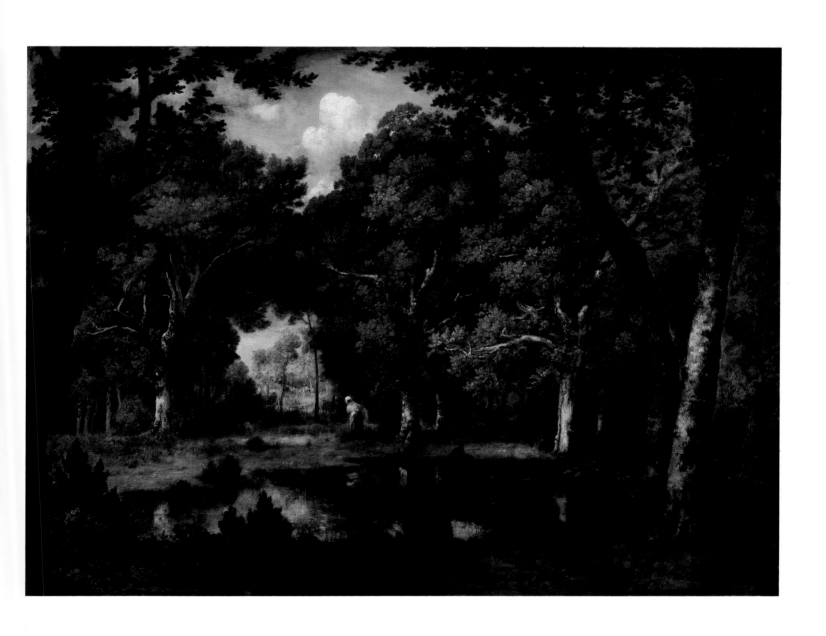

Edgar Degas
The Young Spartans
1859-60

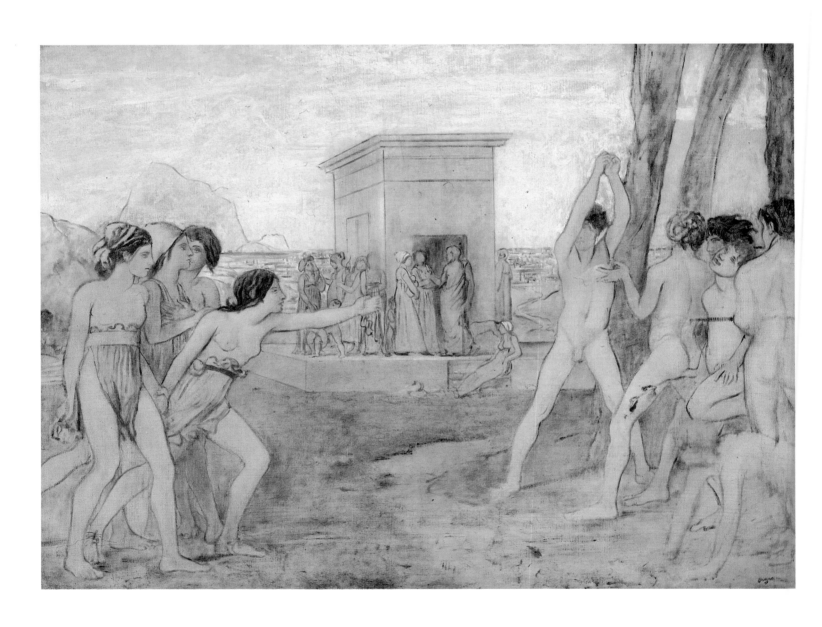

The *Young Spartans* is, in a sense, a failed Salon painting. Edgar Degas never made his mark in the official exhibitions, despite the fact that he spent nearly fifteen years trying. His failure was inevitable, because his aims were more subversive than conformist and ultimately criticized the kind of painting sanctioned by the Salon.

Degas was a young artist when he made this painting, and his most obvious model was the greatest Salon painter of modern France, Jacques Louis David. Degas's use here of a bilaterally symmetrical composition, with a strict division of the sexes and generations, has its roots in paintings like David's *Oath of the Horatii* of 1784, now in the Musée du Louvre, Paris. Clearly, Degas's picture was not painted in homage to David, but rather was intended as a cynical criticism of the pictorial and social values embodied in the earlier artist's famed, official canvases. Everything about *The Young Spartans* turns the official order of David's prototypes on its head. Whereas the men act and the women react in David's world, here, in Degas's, the young women take the initiative and the men respond to the women's aggressive gestures. While David and most academic painters of the eighteenth and nineteenth centuries chose glorious moments in the history of Rome or Athens, Degas "glorified" a scene of daily life in the less admired ancient city of Sparta. And, unlike David's carefully finished paintings, Degas's is unfinished, possibly in deliberate emulation of the "unfinished" masterpiece by the young Leonardo da Vinci, *The Adoration of the Magi* of about 1478-81, which Degas studied in the Galleria degli Uffizi, Florence, in 1857 and which was definitely the source for the mountainous landscape in the background of *The Young Spartans*.

As a young painter, when he first began *The Young Spartans*, Degas was deeply affected by the art of the Italian Renaissance, which he studied carefully on his many trips to Italy. Indeed, it seems that he preferred the Renaissance to classical antiquity as the proper source for modern art and, in this way as in others, refuted the strictly classical ideas of the French Academy.

Not surprisingly, Degas must have lost his nerve and did not submit this painting to the Salon jury. He did, however, create a second, "finished" version, which can be seen in the National Gallery, London. Most likely begun in the mid-1860s, it was not completed until 1880, when the artist exhibited it at the fifth Impressionist exhibition. By that time, Degas had stopped making satirical Salon paintings and had turned his attention to the modern world explored earlier by his hero Honoré Daumier.

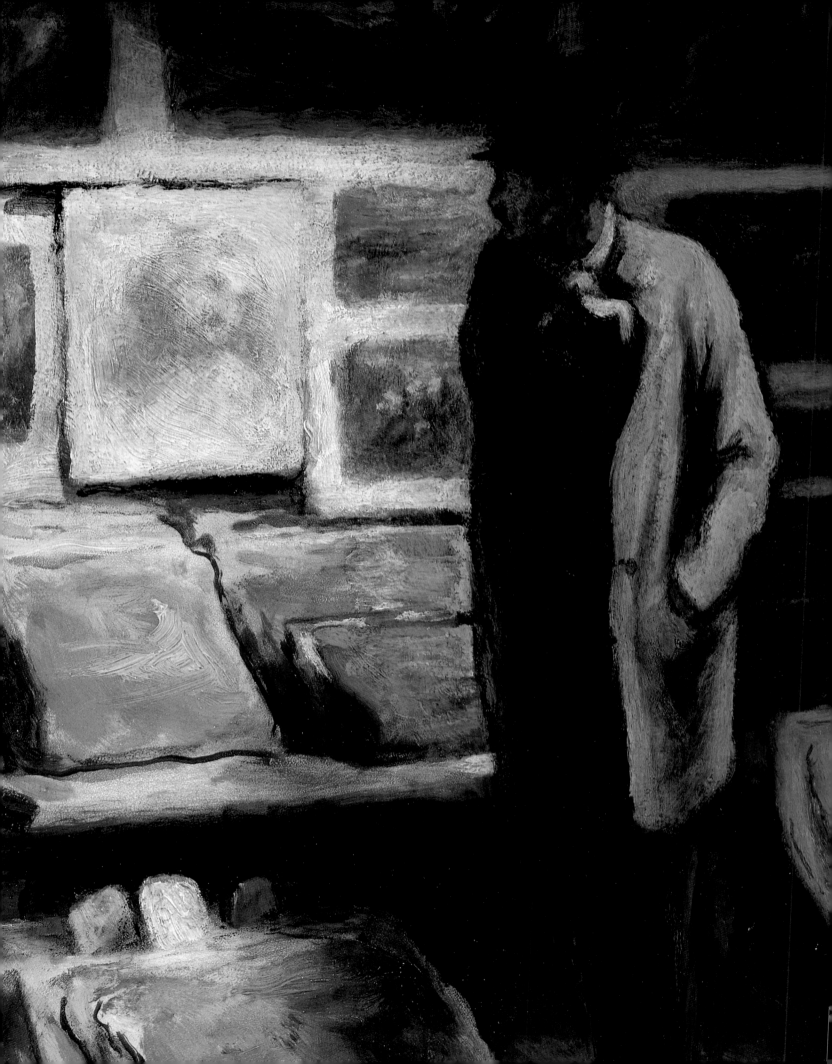

DAUMIER'S COMPASSION

Honoré Daumier was, without doubt, the greatest popular artist of the nineteenth century – popular, that is, because he made works of art for mass distribution in printed form and, therefore, derived his living not from the art world, but from that of commercial printing. For this reason, his paintings, drawings, watercolors, and sculpture, all but unknown during his long career, were only revealed in quantity at a large retrospective of Daumier's oeuvre held in Paris in 1878, the year before his death. Through this exhibition, Daumier became the hero of the young Impressionists, particularly Edgar Degas and Auguste Renoir, each of whom studied the works in the exhibition carefully. In his paintings and drawings, he explored the world of everyday Paris, concentrating on lower- and middle-class life, both public and private. Interestingly, his paintings and drawings tend, more often than not, to simplify or generalize subjects he had previously explored in his published lithographs, as if to render immutable, through the mediums of "high" art, the fragile temporal world of the modern city that he explored in the "lower" medium of lithography.

The Print Collector is the second version of a composition Daumier had already investigated on a smaller scale. It is, thus, a refinement of an established pictorial idea. This was a common practice for the artist, who preferred to repeat his compositions in several scales and mediums, presumably to better extract their essence. His subject is an ordinary-looking man, distinguished only by the extreme attenuation of his body, who stands alone in the enchanting environment of a small print dealer or, possibly, in one of the exhibition rooms of the Hôtel Drouot, the renowned Parisian auction house. The man seems to have paused in the midst of his rummaging. Lost in reverie, he gazes not at the folios of prints and drawings arranged on the table, but rather at what appears to be a red-chalk drawing of the head of a young woman that is caught momentarily in the light. How different this individual is from the aristocrats and wealthy businessmen who spring more readily to mind when one thinks of art collectors in the eighteenth and nineteenth centuries. This anonymous man, modest and of the middle class, is represented by Daumier as capable of intense and refined appreciation of the visual arts. This humble scene of admiration for a single, small-scale work of art must have been, for Daumier, an expression of the capacity of man to seek out and treasure aesthetic experience, despite all else he becomes and is forced to endure in modern life.

The two drawings shown with this painting are selected from the Art Institute's vast collection of graphic works on paper by Daumier to reveal the range of his graphic style and imagery. Both dating from the middle years of the Second Empire (1852-70), they reflect two realms in two different techniques. Drawn in dark watercolors, *The Three Judges*, often called *The Conviction Piece*, is authoritarian and hieratic in composition, revealing quite clearly by the poses and positions of the judges not only their ultimate authority, but also its terrible character. The venal French court system and the corruption, avarice, and arrogance of the lawyers and officials that constituted it were favorite targets of Daumier's political cartoons, which appeared weekly for many years in various Parisian periodicals. In the Art Institute drawing, the presiding figure sits beneath a painting of the Crucifixion, and his gaze is passionless and impenetrable. Daumier did not pre-

sent the judges in profile or in the larger context of their courtroom, but directly and frontally, as if we, the viewers, are being judged. Thus, our role in looking at this drawing becomes not that of a connoisseur, but that of the accused. Whether Daumier intended to use this device as an indictment of his audience is not clear. It seems more likely that he chose to place the viewer in the position of the victim so as to increase our sense of pity for, and understanding of, his plight.

Family Scene, drawn in ink, is in total contrast to *The Three Judges*. Here, an informally asymmetrical composition and an agitated, quivering line inject a sense of life and humanity into this image of a humble, lower-class family on their suburban walk. Unlike many of Daumier's lithographs of family life that satirized the French middle class with the artist's mordant humor, this intimate sketch is rare in its unabashed expression of the bonds between parents and child. An English or American viewer can most easily understand Daumier's world by comparing it with that of the English novelist Charles Dickens, who was always capable of revealing human vitality and compassion beneath the indignities and absurdities that are the products of the bureaucracy and grime of modern urban life. Yet, the artist whose name springs most readily to mind when we look at this delicate masterpiece by Daumier is Rembrandt van Rijn. Daumier was as much a connoisseur of the graphic arts of the past as the print collector in the small painting included here. He seems to have been an assiduous student of the drawings and prints of the Dutch seventeenth-century master. The quality of line in this particular drawing is very close to that in Rembrandt's etchings, particularly those depicting the humblest subjects. Like Rembrandt, Daumier was able to represent in pictorial form both the purity and impurity of mankind.

Honoré Daumier
The Print Collector
c. 1857/63

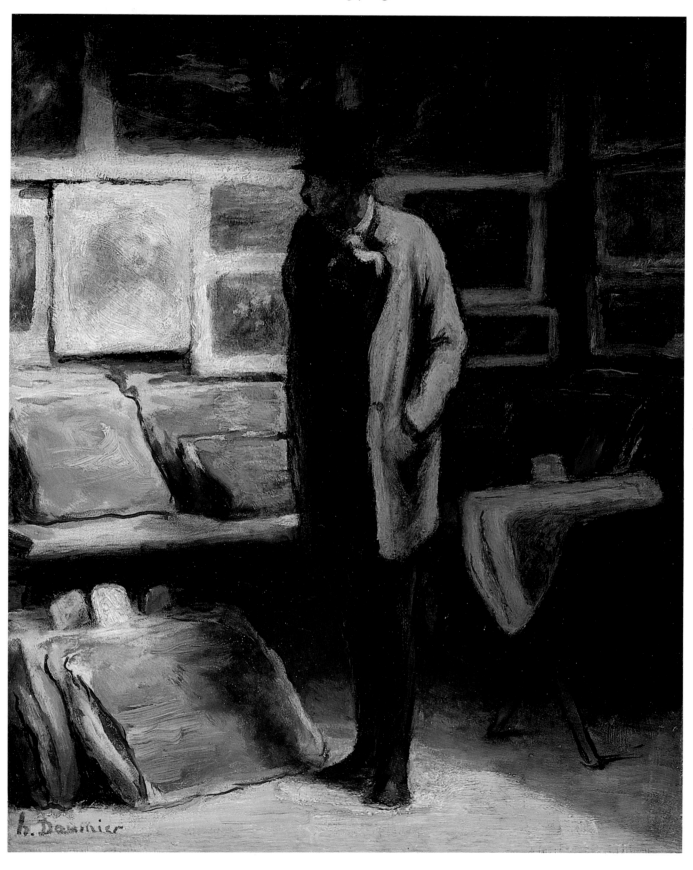

Honoré Daumier
The Three Judges
c. 1855/58

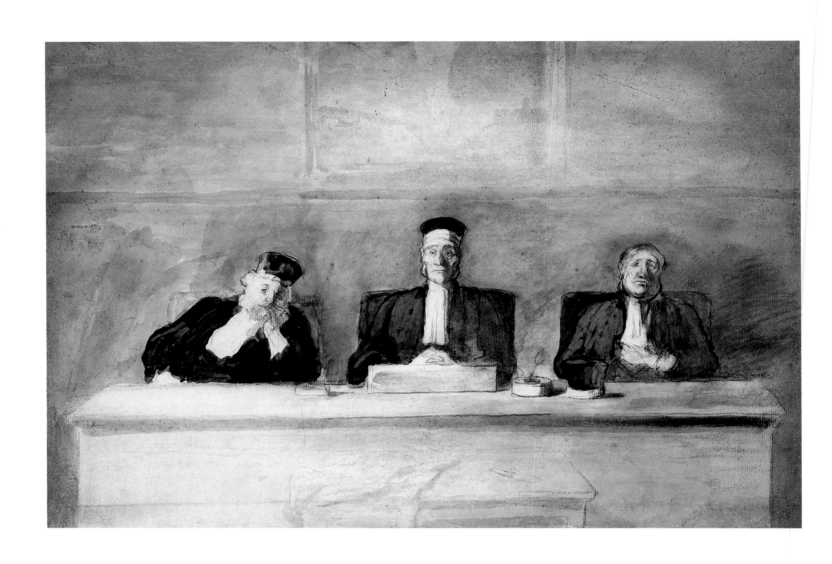

Honoré Daumier
Family Scene
c. 1865

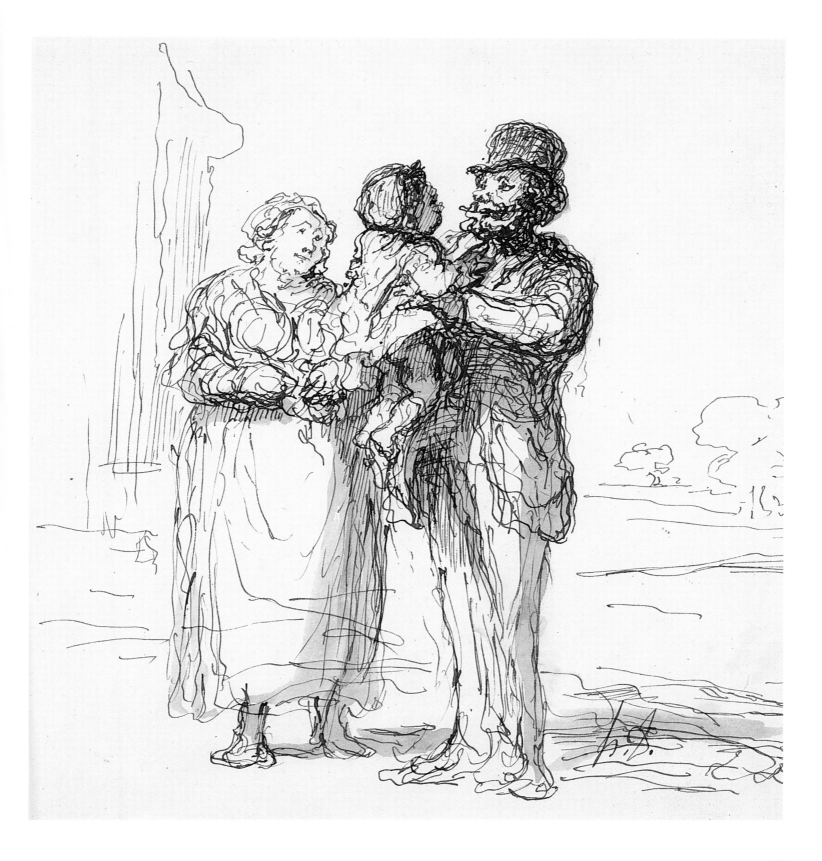

Edgar Degas
Self-Portrait
1857

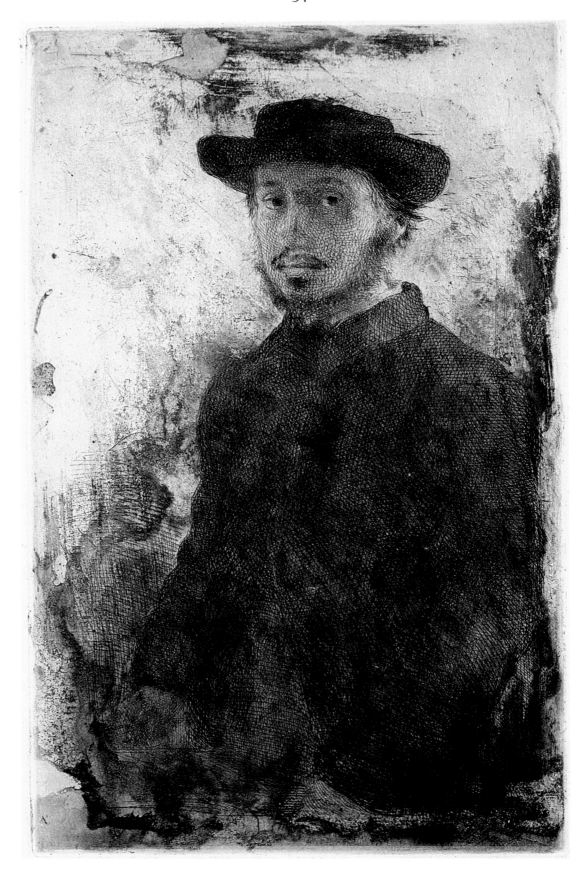

Most modern histories of the Salon pay inordinate attention to the paintings submitted to these immense exhibitions and give short shrift to works in other media. Recent study of sculpture at the Salon has helped redress the imbalance slightly, but little research has been done on the prints and drawings shown there. The fact remains that Salons throughout the century included many works on paper, catalogued either separately or, in the case of drawing, listed with painting. Most of the official publications of the Salons were cross-referenced so that the viewer could easily find works submitted in several media by a single artist. However, in the exhibitions themselves, the graphic arts were hung separately from the paintings, and many contemporary visitors and reviewers never even toured the section.

Although not submitted to the Salon of 1857 – the year it was made – Degas's superb etching is without doubt his finest from the 1850s. During the decade, he had learned the medium from the master engraver of the day, Joseph Gabriel Tourny, who made his debut with two portrait etchings at the Salon that year. Tourny taught Degas the technique of etching, but the young artist's real source of inspiration lay further back in the history of art, especially in the etched self-portraits of Rembrandt van Rijn. With his own *Self-Portrait,* Degas became the first great modern artist to participate in what was to become an etching revival, which flourished in the early 1860s. For Degas, as for many artists who actively contributed to this revival, each print from the plate was considered an individual object, as unique as a drawing or a painting, largely due to the artists' special manipulations of the inking, the paper, and the pressure of the press.

Self-Portrait is among Degas's most experimental etchings, and no two proofs of this rare print are alike. Of these, the Art Institute impression is among the very finest to survive, and, had it been sent by the shy young artist to the Salon of 1857, it would have been, without question, the finest print of that year.

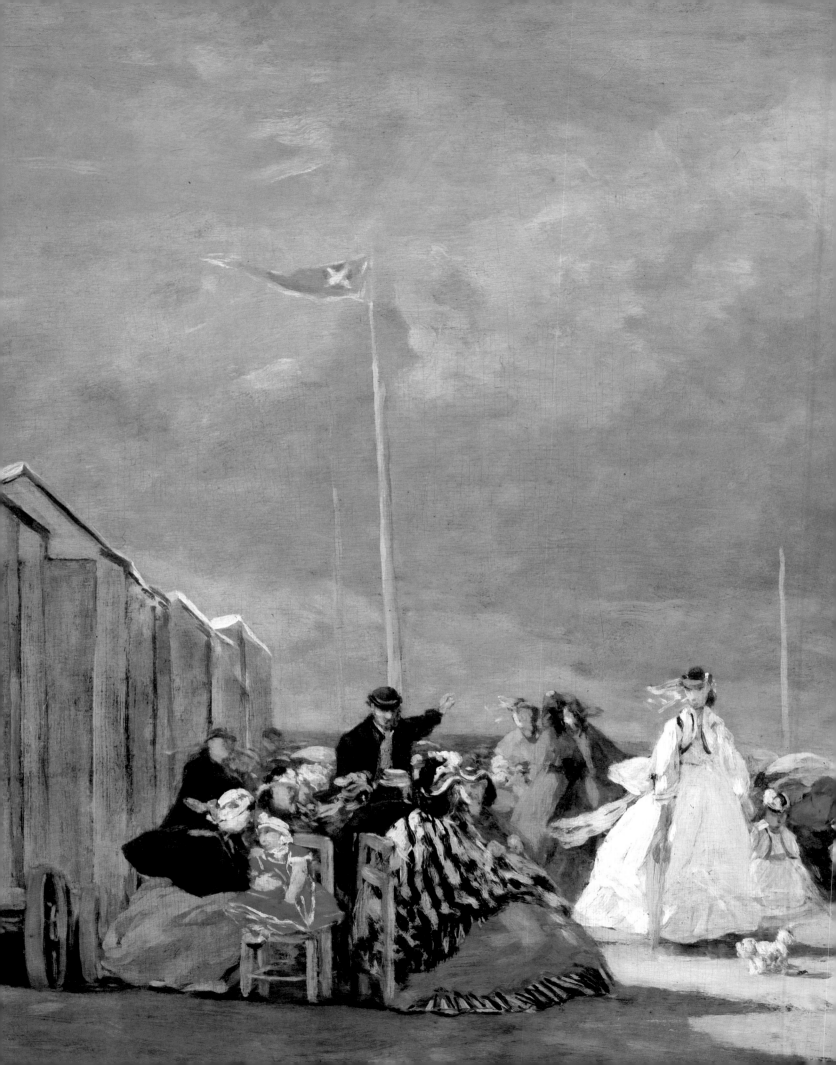

THE SALON OF 1864

The jury for the official Salon of 1863 had been so severe in their judgments that the public outcry moved Emperor Napoleon III to call for an exhibition of the rejected works. That famous and controversial "anti-Salon" came to be known as the *Salon des Réfusés*.

Needless to say, the heated climate of debate insured that the jury for the next official Salon, that of 1864, was more democratically chosen and, in the end, more liberal in admitting work by new artists. No individual was allowed to dominate. Unacclaimed artists like Pissarro, Boudin, Renoir, and Morisot, who later exhibited with the Impressionists, were represented by the same number of paintings as such celebrated figures as Delacroix, Gérôme, and Corot. The range of achievement was extraordinary, and it is possible to argue that, of all nineteenth-century Salons, the one of 1864 was the most representative of the period's artistic activity.

The Art Institute is fortunate to own several important paintings from the "democratic" 1864 Salon, four of which are reproduced here. The greatest of them is without doubt Millet's *Bringing Home the Newborn Calf*. The painting received intense criticism; its peasant figures were described by the critic Ernest Chesneau as "types of cretins from the countryside." The solemnity with which Millet imbued so common and, to certain tastes, so vulgar a subject was considered offensive. Yet, in style, *Bringing Home the Newborn Calf* is among the most gentle, lovingly painted pictures of Millet's career. Each form, whether a stone, a man, or a tree, seems perfectly distilled from nature, conveying a message of pantheism, rather than vulgarity.

One of the most luminous and grand landscapes in the exhibition was painted by the now obscure Provençal landscape painter Paul Camille Guigou, who died at the age of thirty-seven before fully maturing as an artist. His entry, *The Banks of the River Durance at Saint-Paul*, must have glowed from the wall, its blue Mediterranean sky sliced by the bright, dry soil of Provence and reflected in the waters of the Durance River. Composed as a series of stark planes, strictly parallel to the picture surface, the painting has an almost raw modernity and strength.

Eugène Boudin, a Norman painter and teacher of Claude Monet, was admitted to the Salon with a work that exemplifies his oeuvre in the 1860s. It is easy to see, when confronted by Boudin's *Approaching Storm*, what inspired Monet's frankly modern, "fashionable" beach landscapes. Indeed, Monet followed his teacher's practice of painting in the open air, a practice that gave this image of a bourgeois beach setting its vivid spontaneity and atmospheric light. Because Boudin did work quickly and at least partly out-of-doors, his paintings of the 1860s have an almost abstract quality.

Although rooted firmly in the Dutch landscape tradition, the quickly painted "impression" of a wind-whipped ship arriving at a harbor in Johann Barthold Jongkind's *Entrance to the Port of Honfleur* reminds us of later seascapes by Monet, Alfred Sisley, and even Camille Pissarro. Where younger painters derived many of their methods of pictorial construction from Boudin, what we might call "the Impressionist touch," the loosely applied line or dab of paint, has its roots in the art of Jongkind. Unquestionably, the veritable encyclopedia of French art that was available at the Salon of 1864 was critical to the development of what were to become known as Impressionist imagery and style.

Jean François Millet
Bringing Home the Newborn Calf
1864

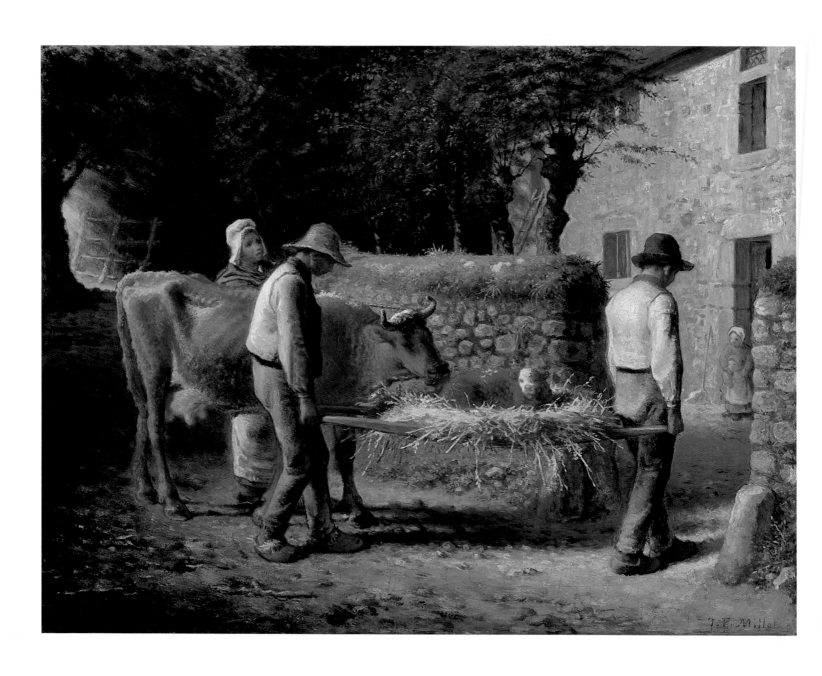

Paul Camille Guigou
The Banks of the River Durance at Saint-Paul
1864

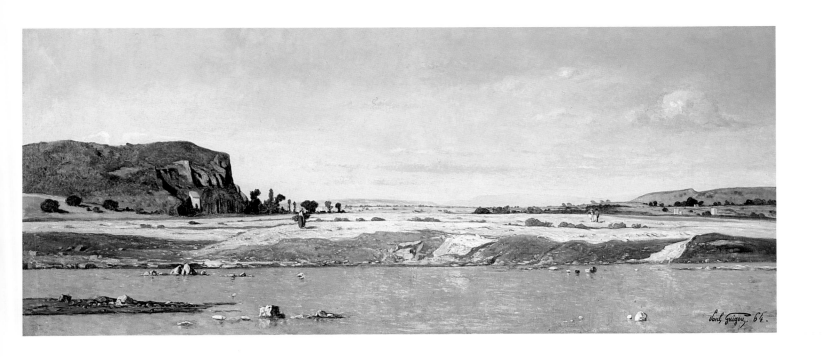

Eugène Boudin
Approaching Storm
1864

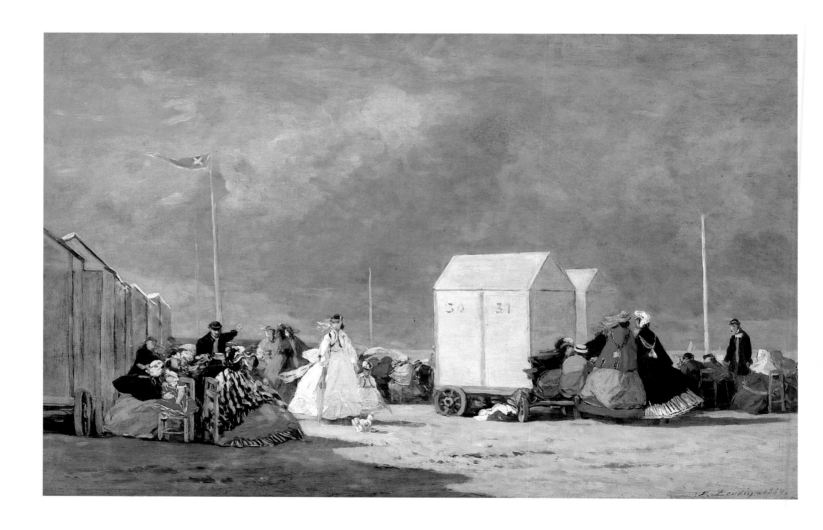

Johann Barthold Jongkind
Entrance to the Port of Honfleur
1864

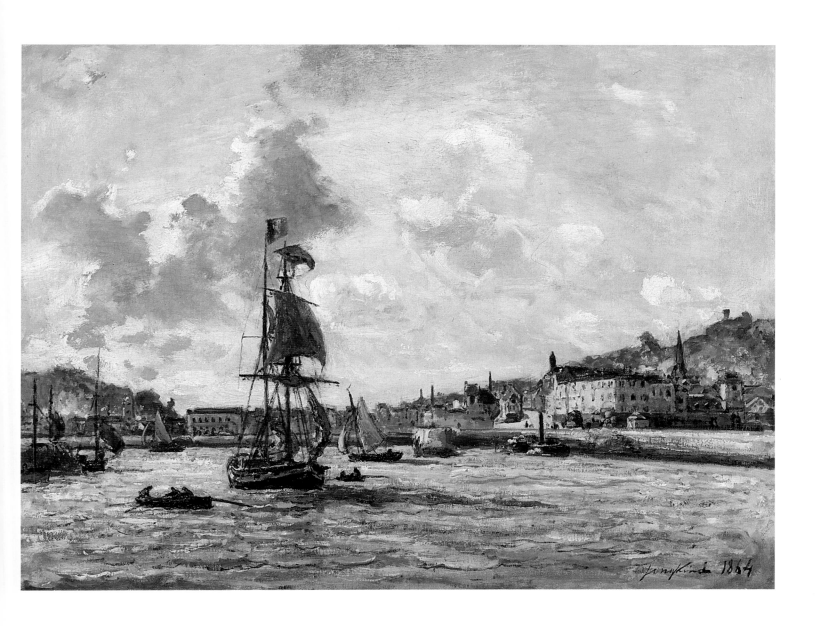

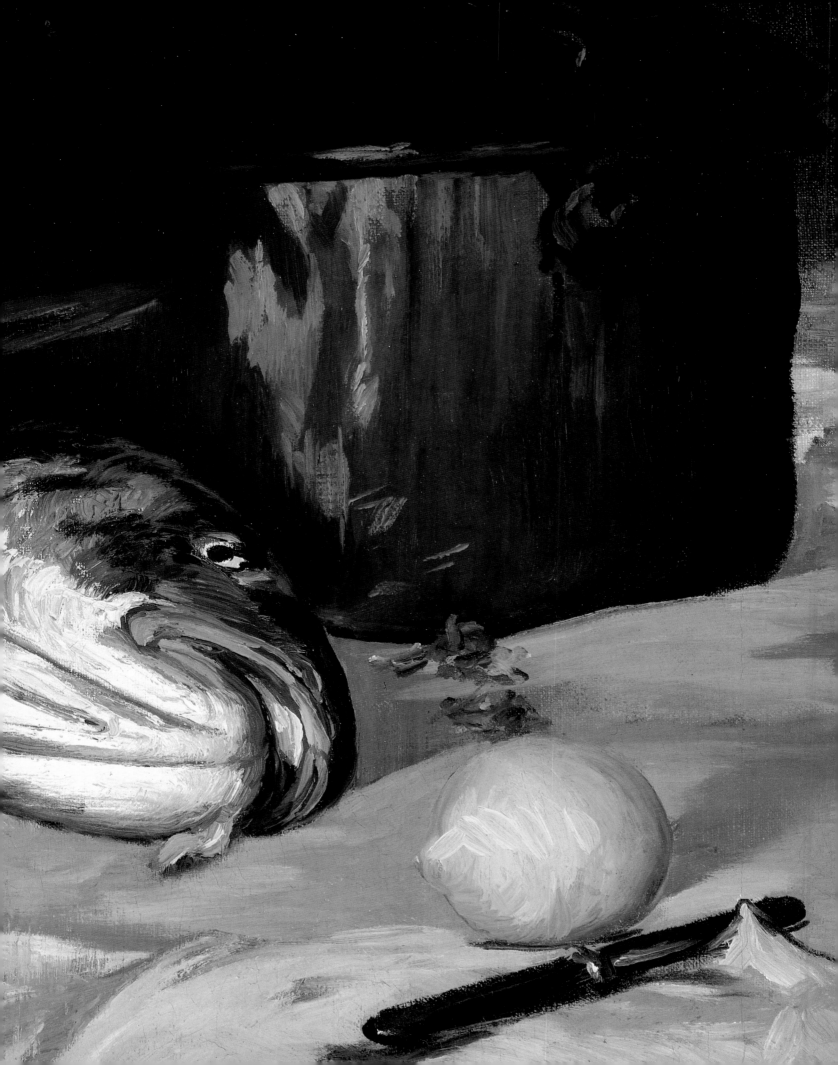

MANET IN 1864

The attention and outrage of all Paris was focused on Edouard Manet at the 1863 *Salon des Réfusés*. There, amidst the darkened landscapes and numerous mediocrities of "the refused" hung his *Luncheon on the Grass*, now in the Musée d'Orsay, Paris. In a landscape that looked for all the world like the fashionable Bois de Boulogne, a group of urbane, fashionably dressed males, enjoying a picnic, pose with a woman who is unabashedly naked, her clothes tossed carelessly aside and her bold gaze trained on the viewer. Manet's innovative style, with its flat and unmodeled forms, was as alarming a challenge to academic conventions as was his daring subject matter.

In 1864, while vacationing in Boulogne-sur-Mer, Manet painted a group of superb seascapes and still lifes, of which the Art Institute possesses two of the boldest. He was recovering, perhaps, from the devastating reviews he received for his two submissions to the Salon of that spring, *The Dead Christ with the Angels* (The Metropolitan Museum of Art, New York) and *Incident in the Bullring* (of which two fragments still exist: one in the Frick Collection, New York, and one in the National Gallery, Washington, D.C.) and found the painting of sea views and still lifes at once easy and therapeutic. In many ways, the paintings from that summer were exercises in bravura brushwork. Certainly the slimy assortment of a carp, two red fish, some opened oysters, and an eel in *Still Life with Carp*, or the water, clouds, smoke, and wind of *Departure from Boulogne Harbor,* would have sorely taxed the powers of a lesser painter.

In the still life, Manet chose a large, horizontal canvas and placed the great dominating carp at dead center. The fish seems even larger and heavier than life, as it curves toward us in front of the immense copper pot in which it will receive its final ablution. The oysters – some shucked, others not – appear almost to shriek in the corner of the painting, and both the red fish and the little eel seem desperate to escape their fate. The knife and requisite lemon rest in a state of readiness to perform their parts in the act of preparation; the water from the oysters and the fish has soaked into the tablecloth on which they inexplicably rest. As always, Manet has managed to conjoin the vulgar and the refined by placing his kitchen still life on a white tablecloth appropriate for the final meal, when it ought properly to be on a plain, wood kitchen table. The sources for Manet's composition have often been thought to be Dutch, but the still lifes of the eighteenth-century realist Jean Siméon Chardin and the kitchen scenes of fish and copper pots done after the 1850s by François Bonvin seem to have been more influential. As always, Manet triumphed over his sources.

The seascape is identical in size to the still life. Yet, where the still life is dark, heavy, and almost oppressive, the seascape is light, airy, and spacious. As with all his seascapes from the mid-1860s, Manet chose a high horizon line, responding, most likely, to the way in which the English Channel was viewed from the hillsides surrounding the city of Boulogne, where he painted. The greenish blue water was created with wet blue pigments mixed with wet paint of other hues to intensify the liquid character of the sea. The boats, mostly small fishing craft and one coal-driven tug, cavort in seemingly random rhythms across the sheet of blue-green water, maritime passers-by trapped in paint by the ultimate artist-boulevardier.

Detail of
*Still Life
with Carp*

Edouard Manet
Still Life with Carp
1864

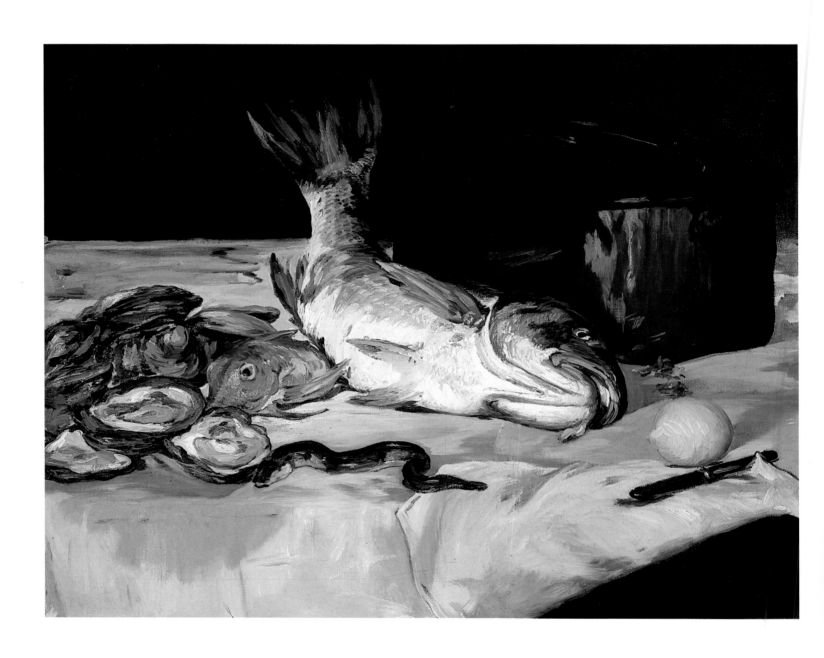

Edouard Manet
Departure from Boulogne Harbor
1864/65

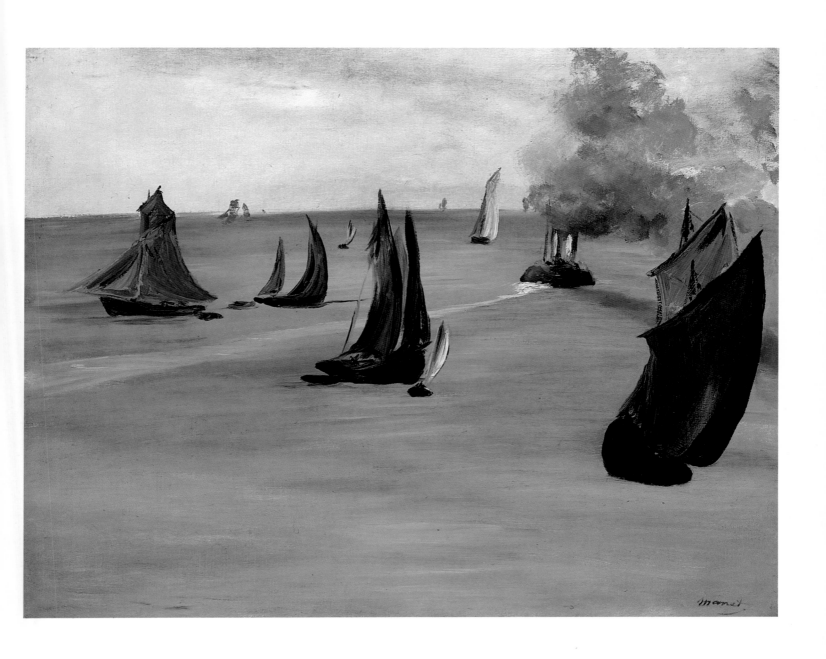

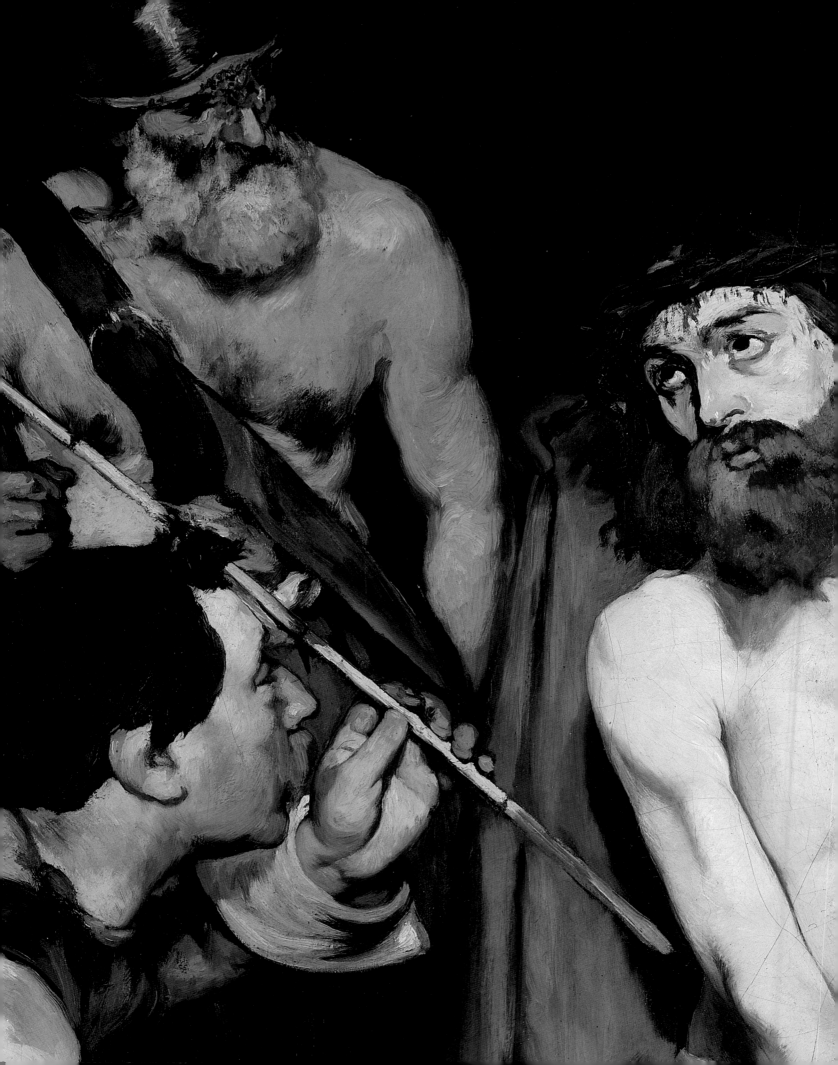

MANET'S RELIGIOUS SUBJECTS

Modern French painting, particularly following the Realist revolution of the 1850s, was profoundly secular in character. Few avant-garde artists, in the last half of the nineteenth century, received important religious commissions, and the vast majority of paintings from the period 1850-90 that we admire today represent either landscapes or contemporary urban life. For this reason, one confronts with surprise the two great religious paintings by Edouard Manet, *The Dead Christ with the Angels* (The Metropolitan Museum of Art, New York), which was exhibited in the Salon of 1864; and the Art Institute's *Mocking of Christ*, accepted for the Salon of 1865, along with the scandalous *Olympia* (Musée d'Orsay, Paris). Why did Manet, an urbane and seemingly secular artist, attempt to paint two immense canvases of Christ?

This question is as difficult for us to answer today as it was for Manet's contemporaries. The paintings were mostly reviled by the critics for the vulgar, lower-class people the artist chose as models, and for his apparent refusal to idealize them in any way. Critic Théophile Gautier decried that "the artist seems to have taken pleasure in bringing together ignoble, low, and horrible types…," and others were even more scathing. Subsequent historians and critics have found *The Mocking of Christ* at once unsuccessful and unresolved, and neither it nor the Metropolitan's painting was included in the first major Manet retrospective of 1884, although they were each readily available to its organizers. Manet, the modern artist, has never been easily integrated with Manet, the Christian.

Like most Frenchmen of the nineteenth century, Manet was raised a Catholic, and his early life was organized around the central rituals of the church. However, unlike many of his well-educated contemporaries, particularly artists and writers, Manet maintained close ties to the church throughout his life. This does not mean that he was a pious, conservative Catholic – such an idea would be antithetical to everything else we know about Manet. Yet, he had more than a casual familiarity with the progressive wing of the Catholic Church in France and was a lifelong personal friend of several important clerics.

One review of the Salon of 1864 connected *The Dead Christ with the Angels* with the infamous French theologian Joseph Ernest Renan, whose first volume of *The Life of Jesus* appeared in 1863, the year Manet began this first great religious painting. The following year, 1864, saw the publication of the second volume and Manet's painting of *The Mocking of Christ*, completed in 1865. The close connections between Renan's best-selling biography of Jesus and Manet's paintings have yet to be explored closely. They are, however, undeniable and crucial. Based largely on primary documents, Renan's work was less a retelling of the biblical story of Christ than the re-creation, through texts, of his actual life. In other words, Christ became a man in Renan's book, which was intentionally a biography rather than a hagiography.

Following Renan's lead, Manet borrowed elements from earlier representations of the life of Christ, yet he subjected them to the same radical transformation that he used when adapting other sources, for instance Titian's *Venus of Urbino* of 1538 (Galleria degli Uffizi, Florence), to his *Olympia*. Where Titian's courtesan is a goddess, Manet's goddess is a courtesan. And, analogously, where Titian's

Christ Crowned with Thorns of 1548 (Alte Pinakothek, Munich) is God, Manet's Christ is man. His ruddy flesh and sheer ordinariness astounded contemporary viewers. The almost shocking frontality by which Manet presented his Christ is unceasing in its insistence that we confront his humanity. The artist's bold reduction of the body to essential planes and his virtual elimination of transitional tones in defining these volumes create a palpable, immediate presence whose physicality is undeniable.

As befits the seriousness of its subject, the painting is a veritable symphony of grays and browns, given life by Manet's addition of an occasional bright orange. Each texture, the skin of Christ's head and hands, the fur worn by one of the torturers, the calluses on their feet, the reeds, leather straps, and rough cloth – all are painted with a literalness and materiality that transcend even the example of Gus-

tave Courbet, with whose profoundly secular realism Manet was grappling in this painting.

Manet's original title for the painting was *Jesus Insulted by the Soldiers*. Clearly, Manet did not intend to portray the soldiers' behavior in the way this title implies. (In fact, the oddly ambivalent actions of these figures was noted by the painting's critics.) Far from being the torturers whose grotesque faces and violent gestures populate the history of art, these are men who seem almost stunned in the presence of Christ. The torturer with the rod kneels in homage more than he readies himself for his cruel task; the fur-clad figure at the right holds Christ's cloak as if it were a royal robe. In *The Mocking of Christ*, Manet seems to have suspended time at the moment before the insults occurred, when Christ, in all his humanity, is revealed to us by his eventual torturers.

Edouard Manet
The Mocking of Christ
1865

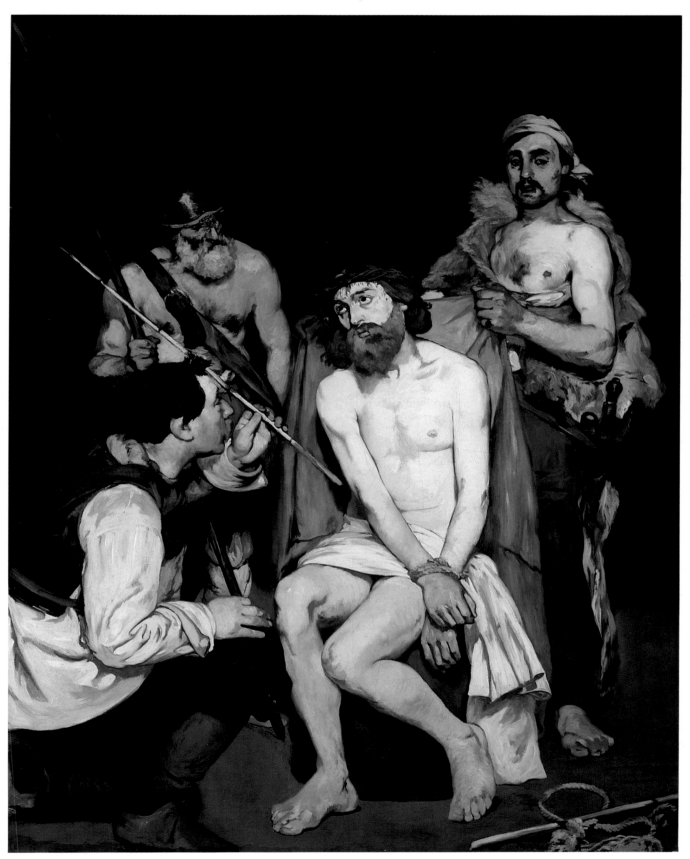

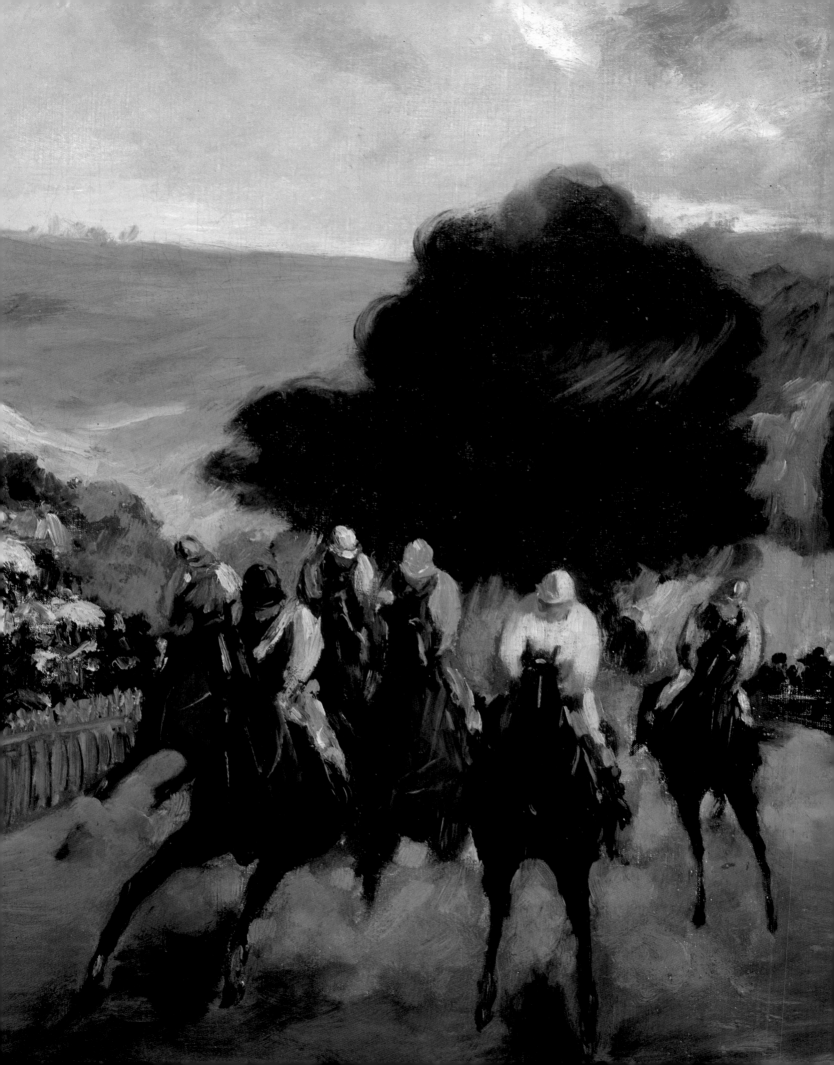

AT THE RACES

Salon exhibitions of the 1840s and '50s bore witness to a dramatic increase in paintings of French landscape and rural civilization, and those of the 1860s announced a growing preoccupation with modern urban imagery. Manet was the leader of this later, iconographic trend, and his *Luncheon on the Grass* (Musée d'Orsay, Paris), shown in the 1863 *Salon des Réfusés,* and *Olympia* (Musée d'Orsay, Paris), exhibited at the Salon of 1865, brought modern life and the world of sophisticated mores directly before the public. The most sought-after subjects of such urban realists were associated with Parisians at play, and the paintings, drawings, and prints they made present Paris in ways quite consistent with the city's self-image as the world capital of leisure and luxury.

Manet explored the parks and boulevards during the daytime and attended the opera and ballet in the evenings. Shortly after they met in 1859 or 1860, Manet and Edgar Degas began to vie with one another to find new cosmopolitan subjects. It was at the horse races that their visual interests overlapped most closely in the first decade of their friendship; these three works of art explore various aspects of this most fashionable of outdoor spectator sports. Although horse racing had long been practiced in France, it had its first great age in the Second Empire (1852-70) during the reign of Napoleon III, when intense anglophilia led to the creation of that most chic of men's establishments, "le Jockey Club." It was during the Second Empire that the splendid racecourse at Longchamps in the Bois de Boulogne was finished, making it easy for residents of the fashionable west side of Paris to go to the races.

Manet and Degas seem to have raced each other to the races, and each of their initial attempts at this difficult subject proved to be a failure. Dating from around 1862, Degas's earliest canvases show a definite dependence on British racing prints and Géricault's considerably earlier paintings of English horse races. By 1863, Manet was at work on a large canvas entitled *Aspects of a Racecourse in the Bois de Boulogne*, intended for exhibition the following year. It seems clear from the surviving evidence that Manet never exhibited, and possibly never completed, the painting, although a highly finished watercolor and gouache at the Fogg Art Museum in Cambridge, Massachusetts, records it in detail. Manet evidently cut the original painting into sections, because two small canvases representing female spectators survive. However, he probably never salvaged the main part of the picture, preferring to create another canvas in 1867, which is now in the Art Institute and is reproduced here.

For Manet, the race itself was a total event. In the museum's composition, for the first time in the history of art, the viewer is startled into believing that he is standing not safely along the sidelines, but directly in the center of the track with six horses charging full speed toward him! This threat to the sense of the viewer's well-being is perhaps the painting's most extraordinary aspect of modernism. The rest of the scene is a blur, brilliantly and rapidly painted so that one's attention cannot deviate from the thundering excitement of the race.

Like Ingres, whom he so admired, Degas was always more analytical and conscious of detail than Manet. He was less concerned with the spectacle of the race itself than with the machinations of the spectators or the periods just before or after the

main event, when the jockeys' movements are slow and deliberate. In *Four Studies of a Jockey*, the riders sit stationary atop their invisible mounts, suggesting that the drawing was made from a model in the artist's studio, rather than from an actual jockey at the race. The same detachment characterizes Degas's beautifully finished portrait drawing of an unidentified gentleman spectator, who himself is on horseback. Interestingly, Degas never used these two drawings as preparations for larger works. Rather, he made them, along with other separate studies of figures at the horse race, to familiarize himself with each aspect of the event. Whereas Manet's impulse was to grasp the essence of the whole visual field and to interpret the race as intensely directed motion, Degas's was to create a grammar of form with which to construct a painting. His earliest successful paintings of the race are just as we would expect them to be, that is, quite the opposite of Manet's *Races at Longchamps*. With their precise, almost enameled surfaces and lack of single focus, they are as radical in their lack of psychological cohesiveness as Manet's painting is in its unity of motion.

Even if he did not share Manet's preoccupation with speed, Degas was no less fascinated with movement. In these sheets, the instability and balance of the riders captivated Degas, and there is a sense in which the artist compared the training and preparation of the race horse with that of ballet dancers. Later in life, he devoted a sonnet to a comparison of horse and ballerina. In early preparatory drawings such as these, he aestheticized the race, emphasizing the aspects of costume and pose that would have appealed to any seasoned observer of court life in either the eighteenth or the nineteenth century. Indeed, for all his vaunted interest in modern life, Degas was less modern than Manet in his mode of representing that life. Surely, it is no accident that his sheet of *Four Studies of a Jockey* is a *mise-en-page* that recalls the drawings of eighteenth-century artist Antoine Watteau, whose interest in depicting rustling silks surpassed even that of Degas.

Edouard Manet
The Races at Longchamps
1864

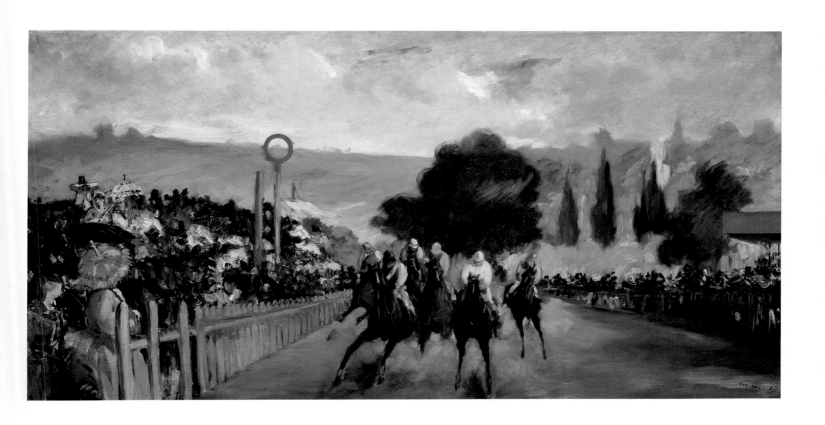

Edgar Degas
Four Studies of a Jockey
1866

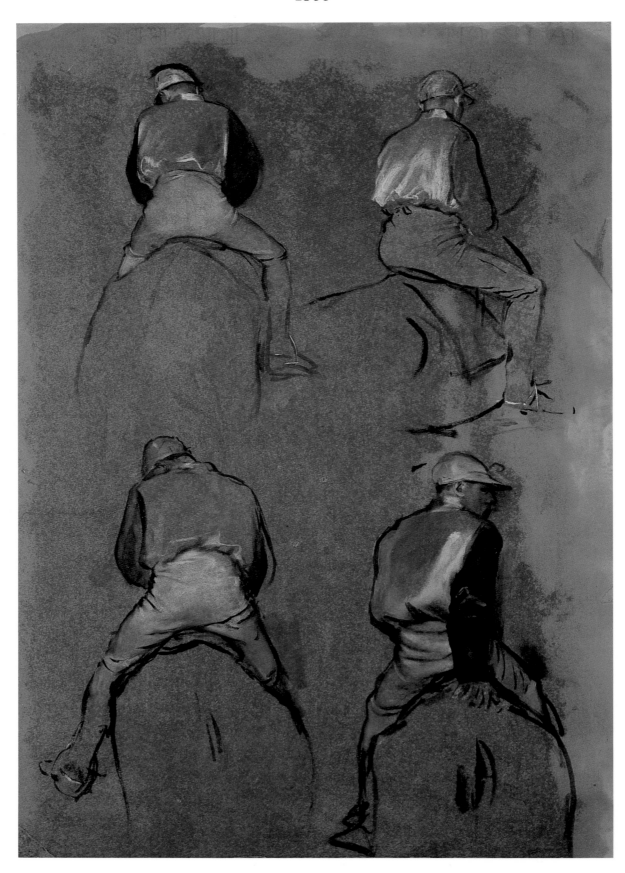

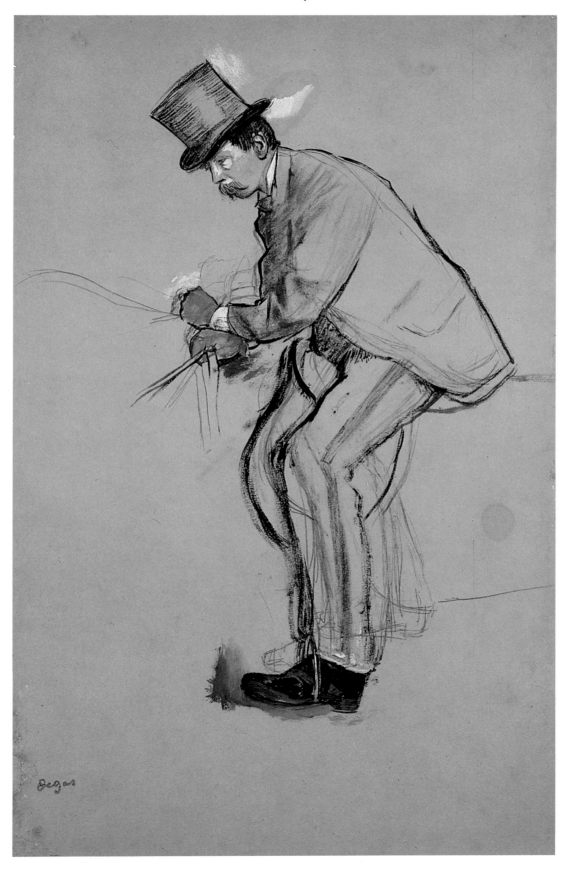

COROT'S ARCADIAN VISION

Edouard Manet, Edgar Degas, and their friends, the Realist painters and writers of the Second Empire, recorded the fashionable habitués of the racetrack, cafe, and theater, but Camille Corot limited his attention to the stage itself, making sketches of romantic and pastoral ballets and operas to use as material for his paintings. A friend of the most progressive artists and a fervent Parisian himself, Corot nonetheless sought to create an art of escape from the anxieties and pressures of the accelerating industrialization and urbanization of life in the last half of the nineteenth century. While the realists haunted the boulevards and brothels in search of modern imagery, the elderly Corot continued until his death to paint arcadian landscapes of rural France and classical Italy. Although it is apparently timeless, his work must be seen as much a response to the city as was that of artists who chose it as their subject.

Nature was Corot's special province. Each year, following the spring thaw, he left his Paris apartment to paint and draw in the countryside and to refresh his sensibilities in the quiet and solitude of nature. When the weather again chilled, Corot returned to Paris in time to create a series of paintings for sale and exhibition during the spring season. He made three trips to Italy, the last in 1843, and their influence lingered long after in his memory and imagination. Corot's "souvenirs" took the form of studio reconstructions or composites of *plein-air* studies done earlier in Italy or France. Created in his mature period, along with his great, lyrical landscapes, these were to become his trademark.

The Art Institute is fortunate to have a splendid example of Corot's important, late landscapes, *Sou-venir of the Environs of Lake Nemi*, submitted by the artist to the Salon of 1865, where Manet exhibited *The Mocking of Christ* (p. 61). While Manet chose to directly confront the religious and moral underpinnings of French society, Corot provided a rose-tinted, ageless landscape in the north of Italy, with a lake warm enough for bathing. Corot's trees have survived the centuries, his town stands unchanged, his rocks are worn and moss-covered. The single figure is a nude male who pulls himself gently from the water after a swim. There is scarcely a breeze to ruffle the reeds or to chill his wet body. The painting actually functions as a souvenir, representing a famous hillside lake in the Italian countryside, which Corot transformed into a personal, bucolic reminiscence by his use of silvery grays and intense, deep greens.

Never shown at the Salon, *Bathing Nymphs and Child* exhibits a similar warmth and easiness. It is one of many hundreds of paintings Corot made in the 1860s and '70s for an immense international market. Where the Salon painting of 1865 represents a real place, the northern Italian Lake Nemi, famous to tourists for generations and painted earlier in the century by Richard Wilson, J.M.W. Turner, Pierre Henri de Valenciennes, and Achille Michallon, as well as Corot, *Bathing Nymphs and Child* is truly set in Arcadia, with a warm, yellow light disappearing behind the trees. There is nothing in this realm to frighten these gentle nymphs, who will bathe forever uninterrupted. If the souvenir of Lake Nemi represents a memory of an aging artist unable to travel again to his beloved Italy, *Bathing Nymphs* must be an illumination of a dream.

Detail of
*Souvenir of
the Environs of
Lake Nemi*

Jean Baptiste Camille Corot
Bathing Nymphs and Child
1855/60

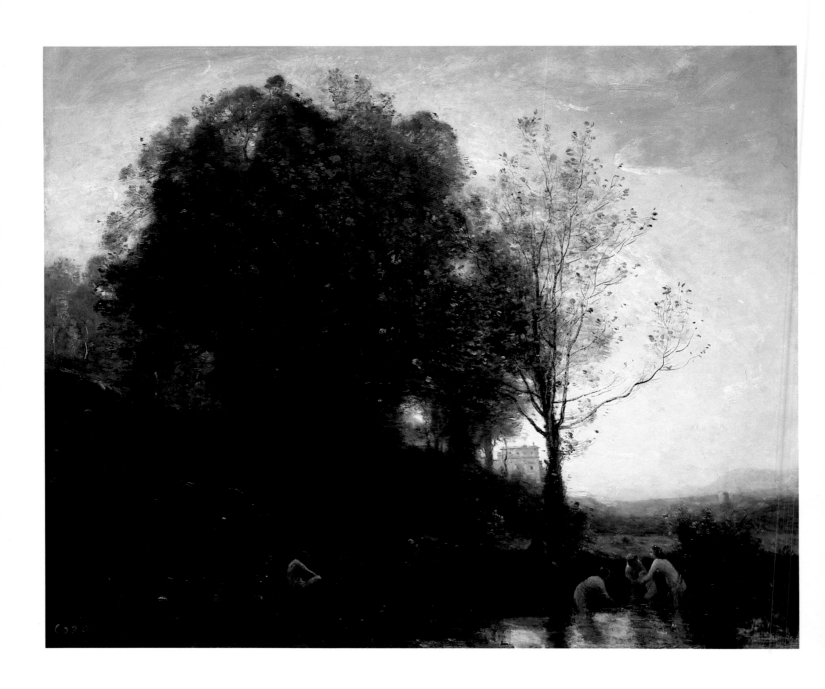

Jean Baptiste Camille Corot
Souvenir of the Environs of Lake Nemi
1865

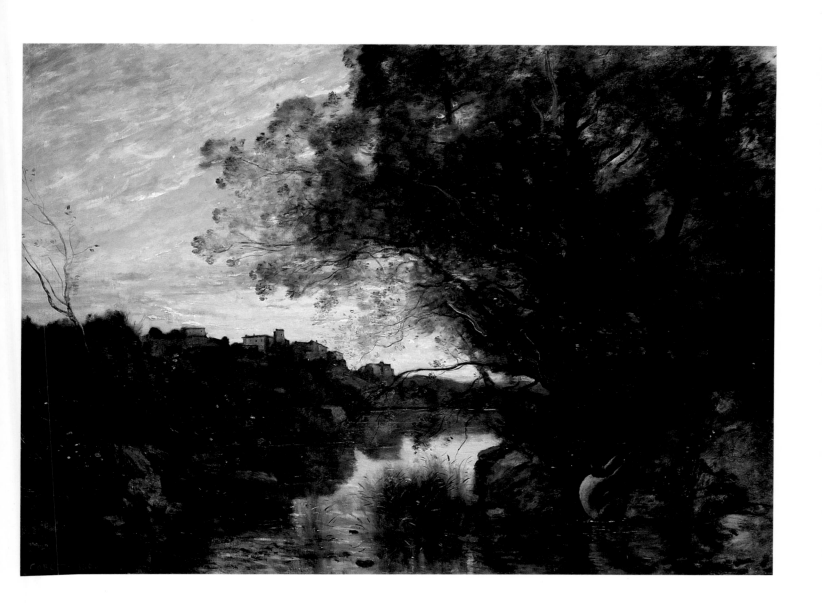

Gustave Doré
The Forest/Alpine Scene
1865

Gustave Doré is chiefly known today as a popular printmaker. His illustrations for books and the press were as famous during his lifetime as those by Honoré Daumier had been for a previous generation. Yet, unlike Daumier, he created large paintings expressly for exhibition and sent them to the Salons between 1862 and 1882, the year before his death. This immense landscape was surely painted for a Salon, yet all attempts to identify it as a specific submission have failed. Its enormous scale and the fact that it was both signed and dated 1865 invite comparison with Camille Corot's Salon landscape of that year, *Souvenir of the Environs of Lake Nemi*, in the Art Institute (p. 71). In contrast to Corot's subtle and spatially complex composition, which is filled with complicated curvilinear rhythms, Doré's is direct, indeed almost confrontational. The viewer is placed in the center of a small mountain ravine surrounded by monumental pine trees. From there, he overlooks a large valley, resembling those of Doré's native Alsace, in the northeastern corner of France. The landscape is powerful and simple, apparently designed to be easily grasped and understood in the context of an exhibition rather than savored slowly by a connoisseur.

The painting has little to do with the canons of landscape construction that were practiced by academic painters like Corot or by "moderns" like Claude Monet and Camille Pissarro. As one might expect from an artist of Doré's background, the painting's geometrically simple and dramatic pictorial construction has its origins in the popular graphic arts, where the aim of the artist is to capture the attention of the viewer more than it is to hold it.

If the painting does represent the landscape of Doré's native Alsace, where the artist returned frequently in the late 1850s and early '60s, it may have appealed strongly to the nationalist sentiments of the French, who had to give up this culturally and linguistically divided province to Germany after the Franco-Prussian War of 1870. Doré, who had chosen to be a Frenchman, would thus have lost these, the forests of his homeland.

Frédéric Bazille
Self-Portrait
1865-66

Frédéric Bazille was in his mid-twenties when he executed this startlingly mature and accomplished self-portrait, and it remains today one of the finest painted in France during the 1860s. Although the artist neither signed nor dated it, the portrait is highly finished and offers close stylistic affinities with other paintings made by Bazille in 1865. It was not sold or exhibited during the painter's short lifetime and remained in the collection of his family until the early 1960s.

The young Bazille represented himself against a subtly modulated, monochrome background and included as props only his palette and brushes. Thus, he portrayed himself frankly and simply as a painter, but without the picturesque clutter of the painter's studio. We confront him, not his environment. The device of isolating the portrait figure on an undifferentiated ground was common in French painting throughout the nineteenth century, but it gained new prominence in the 1860s in the painting of Edouard Manet, whose reductive palette, stark modeling, and bold compositions became highly influential (pp. 56, 57, and 61). Bazille owed a definite debt to Manet, but was certainly not a slavish imitator. Indeed, Self-Portrait has few of the sharp, almost violent juxtapositions of light against dark or the heavy impasto that characterizes the contemporary work of Manet. Rather, it is carefully descriptive, and even timid, in its manipulation of the paint.

Interestingly, many of the nineteenth-century artists who made important self-portraits – Courbet, Manet, Degas, Cézanne, Gauguin, and van Gogh – represented themselves not as artists per se, but as individuals. We can tell nothing of Degas's profession from his etched self-portrait (p. 46), and most of the self-portraits by the other artists include no palettes, brushes, or paints. In fact, these modern artists seem to have been anxious to avoid showing themselves as makers of art. Thus, they saw themselves not as the gods of Neoclassical art or as the heroes of Romantic art, but simply as men and women.

Bazille's Self-Portrait is compelling because of the directness of the pose and the subject's ambiguous psychological relationship to the viewer. While we cannot see them, the easel and canvas must be located immediately in front of Bazille and to our left. He has turned presumably to look at himself in a mirror, and the effect of his turned head is arresting. It seems less that Bazille is painting himself than that he is painting us. He thereby transformed the self-portrait – often an introspective, self-absorbed kind of painting – into a study of the relationship between the artist and the viewer or, in a larger sense, the artist and the world around him. In the end, the painting becomes a work about the inevitable distance between the observer and the observed.

REALIST LANDSCAPES

During the second half of the 1860s, the work of Claude Monet, Camille Pissarro, Alfred Sisley, and Frédéric Bazille was shown side by side at the Salon with that of their mentors and heroes, Camille Corot, Gustave Courbet, and Jean François Millet. Not surprisingly, the younger artists sought to compete in the same arena, choosing sites and styles startlingly similar to those of the older generation. Indeed, far from being rebels against the Salon and its aesthetics, the artists who were to become the Impressionists paid their dues, and many of their greatest early paintings are closely linked to the French Romantic landscape tradition inaugurated at the Salon when they were infants.

Of the three landscapes shown here, only one is known to have been exhibited in a Salon, Pissarro's *Banks of the Marne in Winter*, which appeared in 1866. Its subject is resolutely unpicturesque, almost banal. It is an empty rural winter landscape, its space defined by a row of spindly trees at the left. There are none of the great oaks, the ancient ruins, the warm breezes, and the gentle curves of Corot's Salon painting of the previous year (p. 71). In many ways, this landscape is the opposite of that by Corot, in spite of the fact that Pissarro was among his most gifted and loyal students. Instead of using various brushes to create a beautifully crafted and refined surface, Pissarro laid his paint on heavily, often with a palette knife, in emulation of Courbet. The huge, wet clouds seem to press into the earth, defined as they are by heavy gray and white paint. The whole has a literalness and solidity that moved few Salon critics, but had a powerful effect on the greatest of them that year, the young novelist Emile Zola.

Zola's public exhortation to Pissarro is worthy of quotation. "You should realize," he wrote, "that you will please no one, and that your picture will be found too bare, too bleak. Then why the devil do you have the arrogance to paint solidly and to study nature frankly? Yours is an austere and serious kind of painting, an extreme concern for truth and accuracy, a rugged and strong will. You are a great blunderer, sir – you are an artist I like!" These words – and the painting that inspired them – were profoundly meaningful to Zola's best friend and Pissarro's future student, Paul Cézanne.

While Pissarro carved out his niche in the unpicturesque rural region just east of Paris, the young Bazille sought out the fundamental landscape of France, the Forest of Fontainebleau. His *Landscape at Chailly* was painted at the edge of the forest near the small village of Chailly, less than a mile from Barbizon. Bazille's models for this composition are evident – the Salon landscapes by Barbizon painters Théodore Rousseau (p. 36), Diaz de la Peña (p. 37), and Jules Dupré. Yet, where these artists made the forest into a dark, deep recess for the Romantic imagination, Bazille described a massive and impenetrable wall of foliage, shining brightly under the light of a blue-green sky. The light breaks dramatically across the leaves and reveals the gigantic forms of the rocks for which the Forest of Fontainebleau was famous. No picturesque peasant figures, no mirrored reflective pools, no clearing in the forest is allowed into this utterly factual and, therefore, modern landscape. Again, we should recall the words of Zola, who believed that painting should be "austere," "serious," "rugged," and "strong." In other words, modern painting should be true rather than beautiful.

It is always important to remember that artists

do not necessarily die after the period of their greatest influence and that, often, their best work is done when the limelight of popular attention has shifted away from them. Such was the case for Courbet. He was, without a doubt, the dominant personality in the tumultuous aesthetic debates of the 1850s, when he painted *Mère Gregoire* (p. 30). By the mid-1860s, his reputation was assured, and Manet had become the "enfant terrible," the most infamous painter of Paris. Yet, Courbet continued both to exhibit at the Salon and to create independent paintings of extraordinary strength and beauty. A late landscape, *The Rock at Hautepierre*, painted by Courbet in the latter half of the 1860s, is among the most masterful of that decade: it is every bit as serious and as true as the paintings by the younger artists Pissarro and Bazille.

Courbet never sent it to the Salon: it was too small and unambitious for an artist who had made his reputation with immense canvases. Yet, in this painting of a cliff, a series of peasant huts, a tree, and part of a lake, Courbet constructed a landscape as powerful as any in French painting before Cézanne. Courbet, like Cézanne would later reveal, was deeply affected by the land of his birth, and, in this work, he endowed his home in Ornan with an almost mythic grandeur and simplicity. Courbet's subject is less the specific rock and individual huts of the site than the elemental rocks and dwellings of myth, creating a Realist landscape that is also heroic and Romantic. We are, as the great Romantic poet William Wordsworth put it, "rolled round in earth's diurnal course/ with rocks and stones and trees."

Camille Pissarro
The Banks of the Marne in Winter
1866

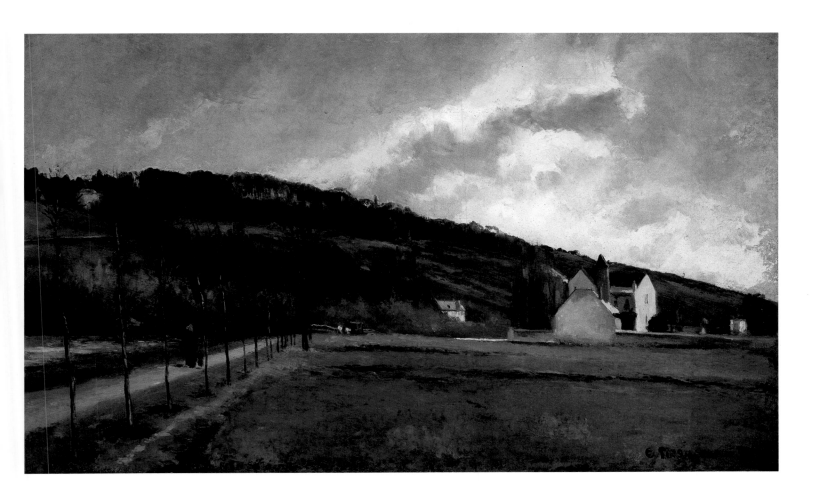

Frédéric Bazille
Landscape at Chailly
1865

Gustave Courbet
The Rock at Hautepierre
1869

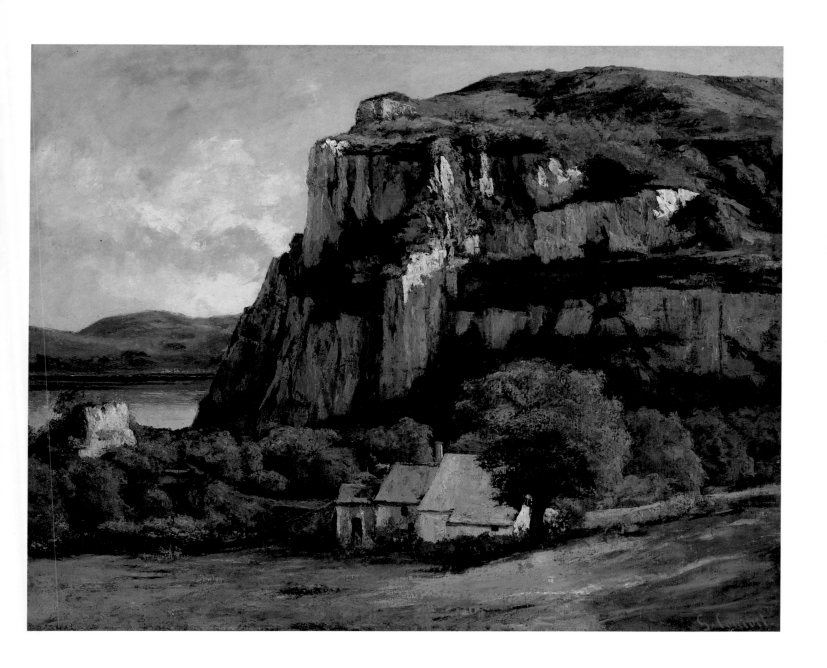

Henri Fantin-Latour
Portrait of Edouard Manet
1867

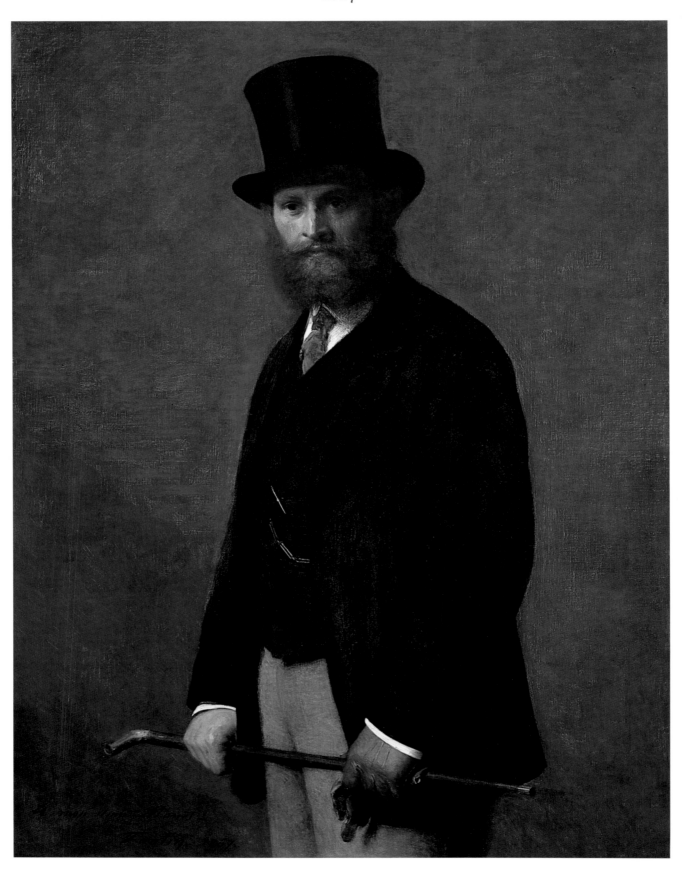

Edouard Manet was at the peak of his notoriety early in 1867, when the young painter Henri Fantin-Latour started work on this famous portrait. Manet's submissions to the Salon of 1866 had been rejected by the jury, and the deeply committed young critic Emile Zola had lost his job at the newspaper *l'Evénement* for his outspoken defense of Manet in his review of that Salon. This led to a relationship between the young novelist and the leading avant-garde painter of France that was to heat up the cauldron of artistic discourse in Paris throughout 1866 and 1867. On January 1, 1867, just one month before Fantin-Latour began work on this portrait, Zola fired a volley at "official" art in Paris by publishing a lengthy biographical and critical study of Manet in the magazine *l'Artiste*. Manet decided not to submit any work to the Salon of 1867, choosing instead to create his own "pavilion" outside the Universal Exhibition of that year.

Yet, Manet was present at the Salon of 1867, not by his own paintings, but by this portrait, exhibited somewhat timidly under the title *Portrait of M.M.* The title fooled no one because the painting was dedicated in large clear script, "to my friend Manet." Even without the dedication, Manet would not have escaped recognition. He was a well-known figure throughout Paris after his scandalous *Luncheon on the Grass* of 1863 and his controversial *Mocking of Christ* of 1865 (p. 61).

Fantin portrayed Manet not as painter, but as a *flâneur*, a sophisticated man about town. He is superbly, but soberly, dressed for an urban outing, his top hat already in place and his hands holding a simple walking stick. The background of the painting is almost completely blank, both in homage to Manet's painting *Fifer* of 1866 (Musée d'Orsay, Paris), which was rejected from the Salon that year, and in emulation of photographic portraits of the period. Although the background of Fantin's *Portrait of Manet* is a gently painted field of gray-beige rather than the flat gray of Manet's *Fifer*, the total effect of Fantin's great portrait is one of extreme simplicity. Only the gold watch chain and the blue silk tie accentuate the outfit of this proper bourgeois. To Fantin, Edouard Manet represented a consummately urban artist whose eyes were open to every nuance of modern life. Manet's image must have seemed to look down from the wall in mute judgment of the Salon that had so recently rejected him.

MILLET'S RURAL LANDSCAPES

The greatest painter of rural life in nineteenth-century France, Jean François Millet exhibited peasant figure paintings at the Salon throughout his long, productive career. He was a native of Normandy, but spent much of his life in the village of Barbizon, creating an enormous body of work that numbers nearly 500 oil paintings and 3,000 drawings, watercolors, and pastels.

Millet's first Salon submissions, in the early 1840s, were portraits, followed by several canvases with classical and biblical themes in 1846 and '47, for which the painter received some notice and praise. Millet came to prominence, albeit a controversial one, after 1848, when his scenes of peasant life were associated with the radical political and social sentiments of the time. His work, along with that of Gustave Courbet, seemed emblematic of contemporary social aspirations for the common man. Millet's *The Sower* (Museum of Fine Arts, Boston), shown at the Salon of 1850, received considerable praise from leftist critics for its epic grandeur; however, his *Man with a Hoe* (Private Collection, United States) of 1863 was met with an impassioned outcry against the sense of hopelessness conveyed by the image of an exhausted peasant at work in the fields.

Such contradictory interpretations and responses to his paintings are easily explained. Millet was not a political reformer; he was a romantic naturalist whose canvases were a complex rendering of his rural boyhood memories, intermixed with his compassion for the human condition – man's struggle against his fate. Essentially a conservative, Millet attempted to preserve in art that which he saw being destroyed by a modernizing society. In this quest, he left a legacy seen in the works of Camille Pissarro, Vincent van Gogh, and Paul Gauguin, artists who also attempted a personal colloquy with nature and sought to infuse their work with pre-industrial values.

During the late 1860s, Millet made a series of four trips to Vichy, where he produced drawings for landscapes in pastel and oil. These superb landscapes were never exhibited in the official Salons, in spite of the fact that Millet began to show landscapes there increasingly after 1866.

In the Auvergne is among Millet's most originally composed landscapes. His rural scenes usually were dominated by almost sculptural figures, which activated the landscape (p. 50). Here we are immediately confronted with a steep, rugged hillside and its worn grasses and straggly vegetation. The high horizon line, uncustomary for painters of the Barbizon School, confines the sky to the corners, yet it is no less powerful for this limited concentration. The subject of the picture seems to be a spinning shepherdess, whom Millet had observed in 1866 and written about to Gavet. She is intent on her work, and her flock scatters across the windswept hill. The painting resembles the earthy landscapes painted by Monet two decades later, even though the Impressionist artist could not have seen it.

Although they are of the same period, Millet's pastel *The Old Mill* is a more typical image and far more conventionally composed than the oil. Its subject, a watermill, has many prototypes in Dutch seventeenth-century landscape painting, particularly in the work of Meindert Hobbema. In making this splendidly rich pastel, Millet was interested less in composition than in capturing a sense of rustling leaves in the wind, the gliding water, and the gentle waddling of the ducks and geese. In its own way, this pastel is as much about movement as is any Impressionist painting that followed it.

Detail of
In the Auvergne

Jean François Millet
In the Auvergne
1866/69

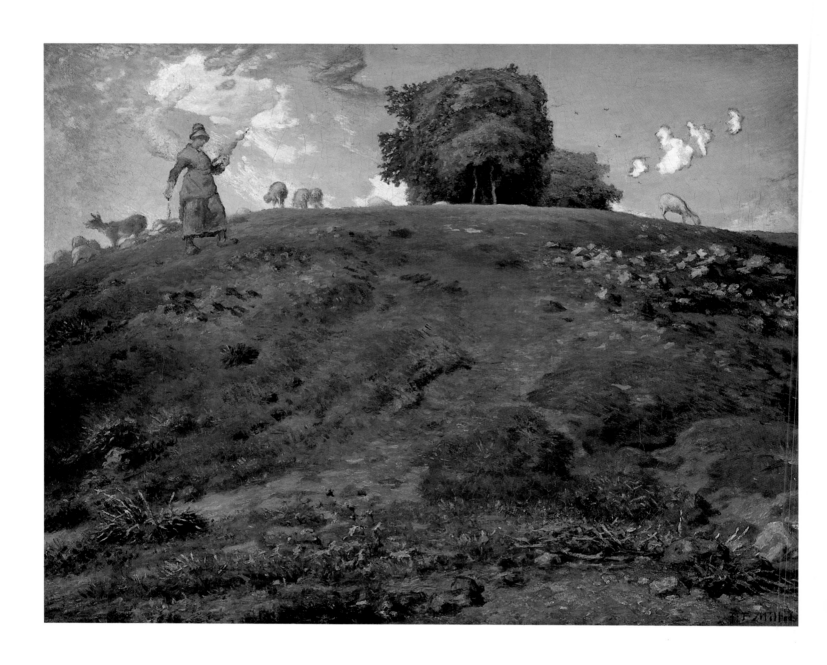

Jean François Millet
The Old Mill
1866/69

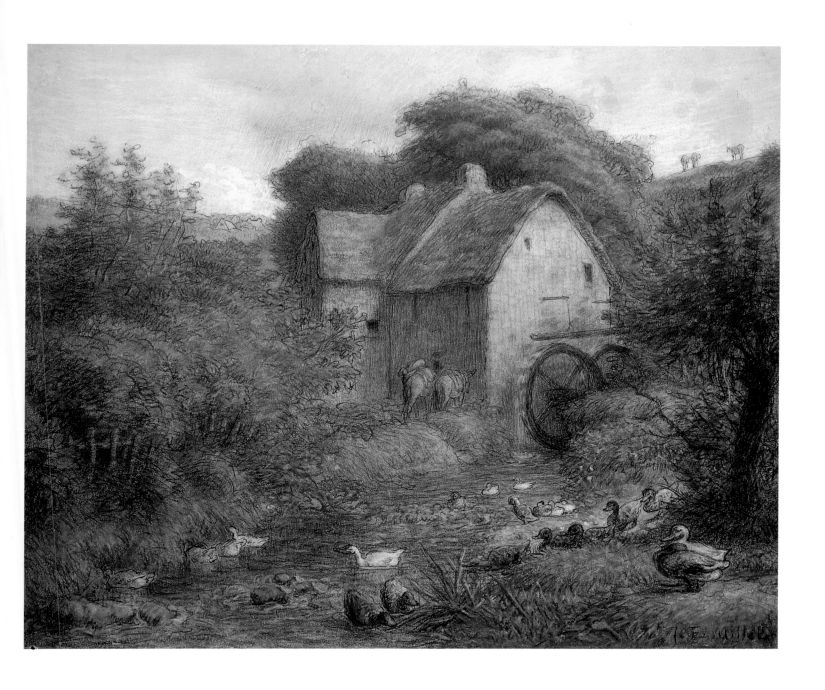

Odilon Redon
Landscape with Oak
1868

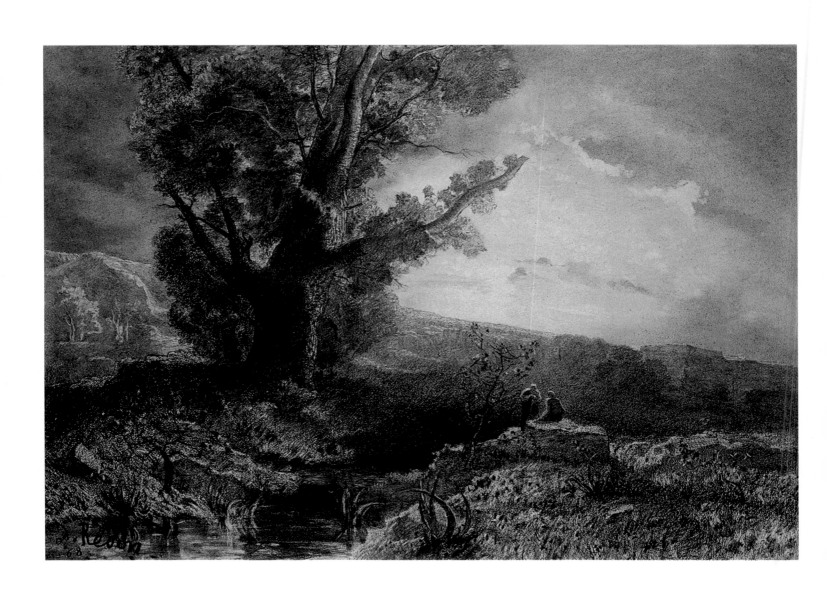

Odilon Redon was among the greatest Symbolist artists of nineteenth-century France. His hallucinatory charcoal drawings of disembodied heads, sightless eyes, and winged horses were called simply *noires* ("blacks") and were a revelation to artists and writers of the 1880s. Redon became famous when the novelist and critic Karl Huysmans chose to include fantastic descriptions of his work in his notorious, decadent novel *A Rebours*, published in 1884. In the latter part of his career, Redon turned increasingly from the graphic media to oil paintings on board and canvas, but the roots of his visual imagination lie in the graphic arts. As a student in Paris during the 1860s, he was a lonely dreamer from the provinces who wrote perceptive art criticism and examined his sensibility in sketchbooks and small drawings. He disliked the academic instruction he received in Jean Léon Gérôme's studio because he was forced to fix the contours of forms that he perceived to be quivering, for it was in the evocation of mood and atmosphere rather than form that he excelled. As he put it, "I have a feeling only for shadows and the apparent depths; all contours are without doubt abstractions."

Redon's first entries to the Salon were large-scale charcoal drawings, of which the Art Institute possesses one of the most noble. Called simply *Landscape with Oak*, it was shown in the Salon of 1868, where it was framed like a painting, but hung with the drawings and watercolors in separate galleries. The oak tree of the title is immense and aged, dominating not only the landscape, but also the minuscule figures conversing quietly at its base. Clearly, Redon's sensibility grew out of the dominant Barbizon landscape tradition. Yet, seldom in the work of Millet, Diaz de la Peña, or even Rousseau does one find the haunting, ominous mood that is so present in this drawing by Redon. Only in Corot's late landscapes does one find the velvety depths of *Landscape with Oak*.

In 1886, Redon set this same great tree into a spacious, conventionally composed landscape called *Night*, a lithograph now in the British Museum, London. Later, in *Trees at Bievres*, a painting of about 1909 in the Museé des Beaux-Arts, Bordeaux, he pushed the tree into the very front of the picture plane, refusing to grant the viewer an escape into meadows and valleys. In the Art Institute's drawing, the tree is a form in nature; in the artist's more mature work, it becomes a powerful and mysterious symbol. What Redon did was to fashion a link between the Romantic imagination of the early and middle nineteenth century and the Symbolist imagination of the century's last decades. This superb charcoal landscape is such a link.

Edouard Manet
Civil War
c. 1871

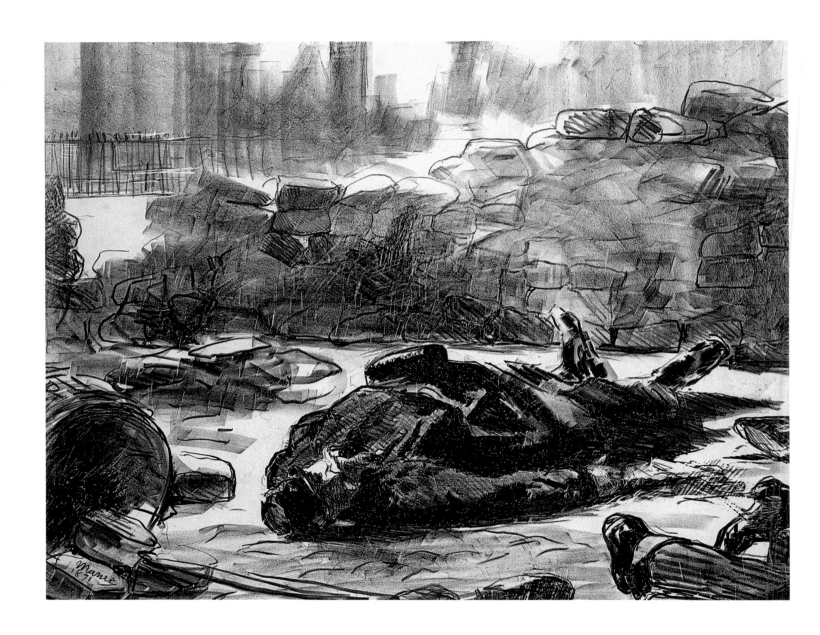

An image of a dead man extends laconically across the center of Edouard Manet's stunning lithographic representation of a scene from the Paris Commune of 1871. His mortal remains – rather than the excitement of the street battles – are the central subject of this work by the great painter and printmaker. There are no flashes of gunpowder, no tense and grimacing soldiers fighting for their lives, no differences between one side or the other. In fact, there is only this single dead man and the barest indications of a setting. Manet's friend, the critic Théodore Duret, remembered that the artist had witnessed this scene on the corner of rue de l'Arcade and the Boulevard Malesherbes, and, with this information, we can identify the lines in the upper left as the columns and iron fence of the Church of the Madeleine. There are two other bodies and part of a cobblestone barricade in the composition.

The deceased was a communard, a member of the radical Republican regime set up in Paris in February 1871. The Commune, sympathetically supported by Manet and many of his friends, was shortlived. It was crushed by the national forces under the government of the great French historian Adolphe Thiers in May of the same year, and Manet's dead communard was one of the conflict's many casualties.

Manet rendered the body with sure, rapid strokes of his greasy lithographic crayon. The directness and vivacity of the drawing lend a sense of immediacy and authenticity to the print, suggesting that the artist transcribed his troubled sensations shortly after the event. Yet, like all else in Manet's oeuvre, this lithograph was carefully and deliberately planned. The pose derives directly from one the artist used earlier for a painting and a print of a dead toreador, but there are also echoes of many newspaper illustrations from the Commune's troubled months, which were published throughout the world in 1871.

Manet's aims in producing this image of a lone casualty of a small civil war seem political, but he did not publish the print in his lifetime, never allowing it to be seen and interpreted by the volatile French public in the decade following what Emile Zola called "the Debacle." Actually, Manet's own political affiliation with the communards was a mute one, and modern students of the artist have preferred, and rightly so, to read this lithograph as a simple testament to the futility of war. In the hand of the central figure, Manet included a white flag of surrender. By the time that this anonymous communard chose to wave it, a shot had already been fired, and he was dead.

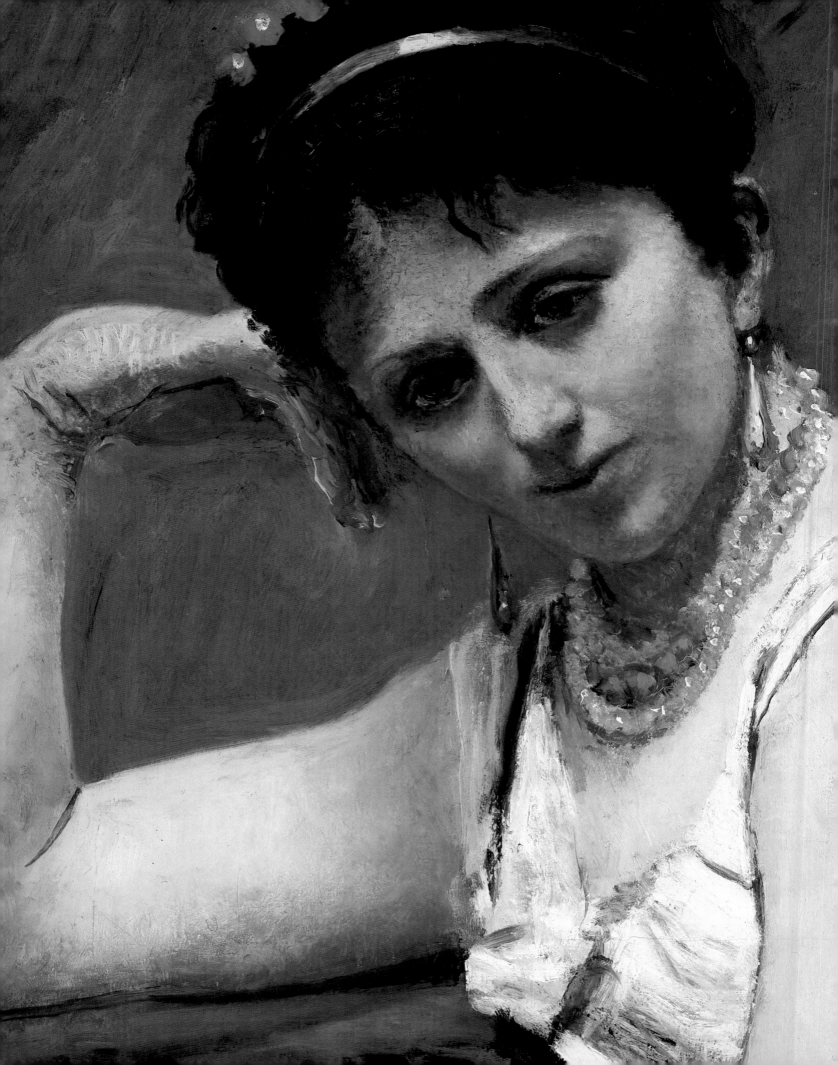

COROT'S FIGURATIVE COMPOSITIONS

Interrupted Reading is among the greatest of Camille Corot's late figure paintings and attests to his position as one of the most important artists of his generation. Unlike most painters of the mid-nineteenth century, he virtually never exhibited paintings of the human figure at the Salon, preferring instead to concentrate on his specialty, French and Italian landscapes (pp. 24, 70, and 71). The single exception was the Salon of 1869, just six years before his death, when he submitted a painting called *The Reader*, but the lithograph made after that painting clearly demonstrates that it was not the Art Institute picture reproduced here.

We do know a fair amount about the history of the large *Interrupted Reading* in the Art Institute. It entered the collection of a landscape painter, Emile Charles de La-Rochenoire, who loaned it to the major Corot retrospective at the Ecole des Beaux-Arts in Paris just after the artist's death in 1875 and who was, in addition, a friend of Edouard Manet. It then passed into the collection of the great novelist and playwright Alexandre Dumas before entering the collection of his equally famous and prolific son. It was acquired from the Dumas estate by the most renowned French art dealer of the nineteenth century, Paul Durand-Ruel, who sold it to Mr. and Mrs. Potter Palmer of Chicago in 1899. The painting entered the Art Institute as part of the Palmer bequest in 1922.

Interrupted Reading represents a model posed in Corot's studio. She is wearing a costume that has been described as Italian but that has only a general relationship to Italian regional attire of the period. It was, most likely, a costume from the ballet or theater, both of which Corot enthusiastically patronized and

where he probably found a good many of his models. While he created landscape backdrops for some of his large figurative compositions, for the most part, Corot's models, like the woman in *Interrupted Reading*, are encased within the intimate, protective environment of a neutral studio atmosphere. The mood created by these figures is contemplative, private, and somewhat melancholic. In spite of her youth and her dazzling jewelry, the woman in the Chicago canvas has an introspective air, as if totally absorbed in her own thoughts, unconscious of the prying eyes of the viewer. She is at once muse and sybil.

Portraits of women holding books were commonplace by the mid-eighteenth century and were fashionable throughout Corot's long lifetime. Corot was not the only great nineteenth-century artist to explore this subject; there are masterpieces in this genre by Courbet, Manet, Degas, Renoir, Pissarro, Gauguin, Redon, Vuillard, and many others. Indeed, the image of a woman reading seems to have had profound symbolic meaning in the nineteenth century, when females who could read, or who had time to read, were actually few and far between. The vast majority of women in every country worked very hard — at home, in the fields, or in some form of public or domestic service — and were illiterate. A woman reading or holding a book, therefore, probably alluded to her significance as a literary muse and to the seriousness or profundity of her thoughts.

In the Art Institute painting, and in many other figural subjects like it, Corot explored the human form as a structure of masses that support and balance one another. These are broadly conceived and defined by steady, moderate light and softly nuanced

color. The broadness of handling seen here is complemented by Corot's obvious delight in subtle detail: for example, the sleek ribbon in the model's hair, her delicate drop earrings, the deep folds in her skirt are all captured with such simplicity and directness that, taken as a whole, the figure attains a robust, almost palpable presence. As in his best landscapes, Corot combined here a profound sense of formal structure with a quality of intimacy that give his images a truly classical dignity and calm, in contrast with the nostalgic or imitative visions that characterize the work of other artists in his generation seeking to re-create the "classical ideal."

As a construction in paint, *Interrupted Reading* is extraordinarily direct, and this perhaps explains why Corot did not send it to the Salon. The model's skirt is defined by frank, even awkward linear marks, and her right arm is painted with viscous skeins of paint that were applied wet on wet. When compared to the contemporary paintings of Manet and Courbet, this canvas is equally bold in its manner of paint handling or facture. Only in its subject matter can the picture be described as traditional. The modernism of its style appealed to Alfred Barr, the great early historian of modern art in America and the first director of the Museum of Modern Art, New York. He included *Interrupted Reading* in a Corot/Daumier exhibition at the Museum of Modern Art in 1930, just one year after the founding of that museum and eight years after the painting entered the collection of The Art Institute of Chicago.

Camille Corot
Interrupted Reading
c. 1870

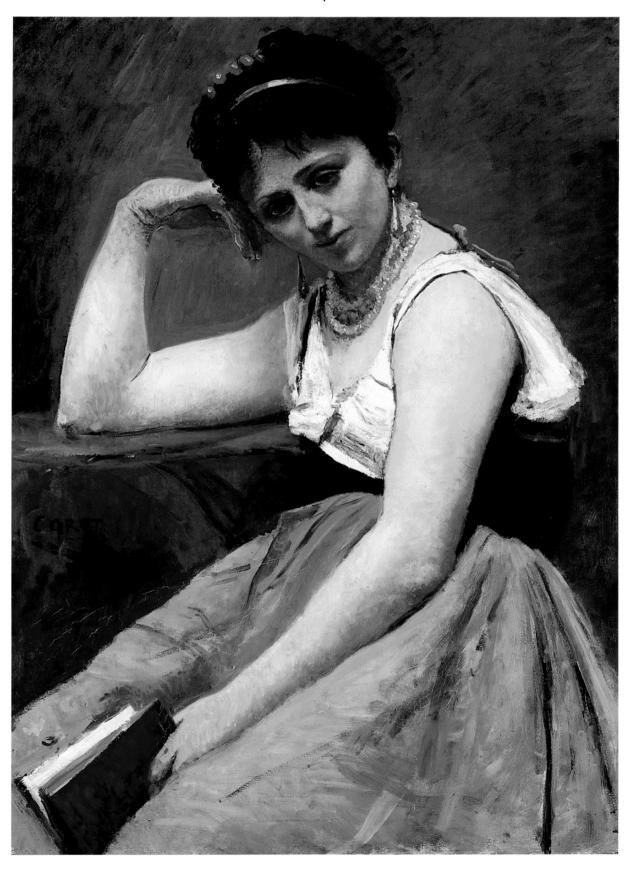

Henri Fantin-Latour
Still Life: Corner of a Table
1873

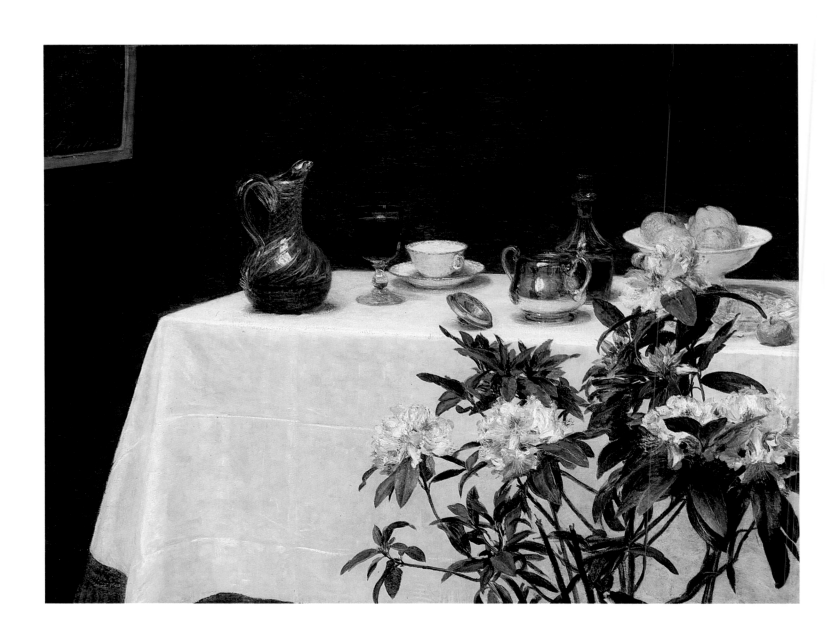

One of the masterpieces of nineteenth-century still-life painting, *Still Life: Corner of a Table*, was painted for the Salon of 1873. That year, Henri Fantin-Latour was enjoying increased public recognition and had just completed a sale of several canvases to the prominent art dealer Paul Durand-Ruel. Having won a medal at the Salon of 1870 for his entry *An Atelier in the Batignolles* (Musée d'Orsay, Paris), he expected to be exempt from jury examination and, therefore, to paint without concern for the whims of the judges. He decided to use the opportunity to execute this ambitious composition.

The painting relates to Fantin's largest and most famous canvas of the decade, *The Corner of a Table*, now in the Musée d'Orsay, Paris. An immense figural composition sent to the Salon of the previous year, that earlier work includes detailed portraits of Paul Verlaine, Arthur Rimbaud, and six of their contemporaries. These major young Parisian poets and writers are carefully placed around a table on which are arranged many of the still-life elements chosen again by Fantin for the composition reproduced here. In both paintings, the tables are covered with a white tablecloth and feature the same wine pitcher, glass of red wine, empty tea cup, sugar bowl, cruet, and glass dish. In the Art Institute version, Fantin made a considered effort to create a "natural," random arrangement of the objects in a room not populated by the human "genius" of young writers, but by the presence of a delicate rhododendron blooming indoors. These flowers, silhouetted against the white tablecloth, are dramatically placed at the front of the picture plane and suggest the influence of Japanese prints, with which Fantin and his contemporaries were quite familiar.

At first rejected by the Salon, but finally accepted in a reconsideration, *Still Life: Corner of a Table* was compared, by some critics, with a group of masterful still lifes undertaken in the eighteenth century by Jean Siméon Chardin, which had entered the Louvre in 1869. Like those of that earlier artist, Fantin's reflective, transparent, and translucent objects give play to gentle indoor light with a wonderful, quiet poetry. Nonetheless, each element retains its separate identity, and, in this way, the painting relates to the great classical tradition of French still life that stretched from Chardin to Cézanne. Indeed, the exquisite subtlety of color and the economy of brushwork make this great still life a painter's painting.

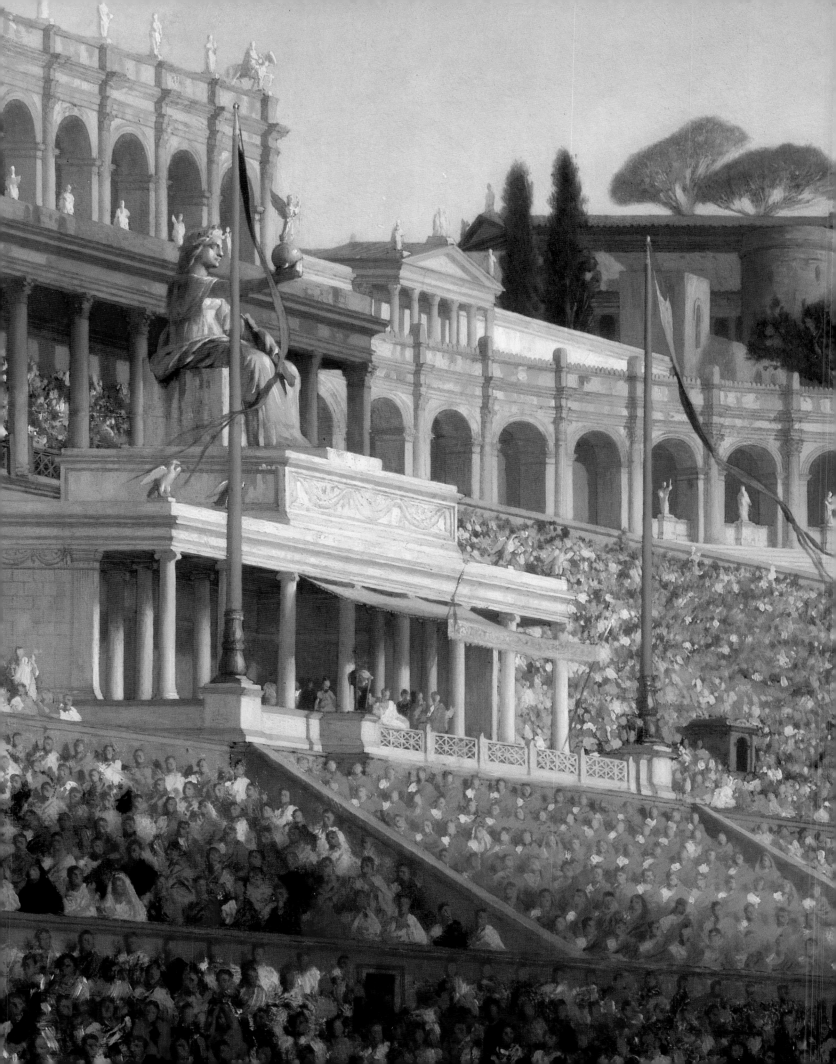

SALON THEMES OF THE 1870S

Although neither of these large, signed paintings were made for the Salon, both could easily be confused with many of the most successful Salon paintings of the 1870s. Each epitomizes a crucial strand of Salon aesthetics during the first decades of the Third Republic (1871-1940): Jules Joseph Lefebvre's *Odalisque* exemplifies Salon eroticism, and Jean Léon Gérôme's *Chariot Race* typifies Salon historicism. Both paintings were commissioned by patrons because of the artists' successes at the Salon, and, although neither work is a replica of any earlier composition, each is a free variation on familiar Salon themes. Through such commissions, both Lefebvre and the much better known Gérôme were able to work directly with their clients, thereby avoiding the intercession of a third party and any taint of "vulgar" commercialism.

Ironically, both of these paintings were commissioned by great American capitalists: the Gérôme by A.T. Stewart and the Lefebvre by John Jacob Astor. In fact, many of the most famous and familiar Salon-style paintings to survive the nineteenth century were made for wealthy Americans for whom Paris had replaced Rome as the centerpiece on the Grand Tour of Europe, and for whom the Salon had become an annual art fair. The great picture gallery that became a standard feature of the houses of American millionaires by the 1880s had to be filled with works of art and, for most Americans, Paris was where one bought them.

It is difficult to imagine a more perfect embodiment of official, Salon art in early Third Republic France than the life-sized *Odalisque*, painted in the year of the first Impressionist exhibition that saw the defection from the Salon of Monet, Renoir, Pissarro, Degas, Cézanne, and other artists. From the almost fetishist treatment of the model's feet to the glistening slave bracelet on her wrist, Lefebvre's nude exemplifies the hot-house bourgeois eroticism for which France was famous throughout the nineteenth century. The oranges, carpets, pillows, and incense are all exotic touches intended to seduce the viewer's senses. The painting is in every way a contrast to Edouard Manet's famous *Olympia* (Musée d'Orsay, Paris), where the nude is frontal and treated forthrightly as a prostitute. A veil of mystery covers Lefebvre's nude, giving her enough respectability to adorn a fashionable drawing room.

Gérôme's painting is scarcely less subtle. His theatrical reconstructions of Roman antiquity were unrivaled until the advent of the Hollywood epic in the twentieth century. Henry James wrote about this picture for the *New York Tribune* after seeing it in Paris before it was sent to Mr. Stewart in New York:

It represents what I take to be the Circus Maximus on a day of high festivity; behind rise the towers and terraces of the Palatine, and into the distance stretches away the vast elipse of the arena. The spectators are embanked above it in high, steep, particolored slopes, the sunshine pouring over them… and touching the reds and yellows of their dresses into gaudiness…. The chariots are eight in number… and each has three horses abreast…. It is a fierce melee of beasts, men and wheels; the struggle and confusion are powerfully expressed, and the horses and chariots painted with that hard, consummate finish characteristic of the author.

The "consummate finish" of Gérôme's racing scene described by James makes it in every way different from Manet's *Races at Longchamps* (p. 65) or any of the racecourse pictures by Degas. For Manet, the rush of the race turned the horses into a blur of dancing strokes, while Gérôme carefully delineated each bulging muscle, each leather strap, each flaring nostril, as if the race were set in amber at a moment in the past.

Detail of
The Chariot Race

Jules Joseph Lefebvre
Odalisque
1874

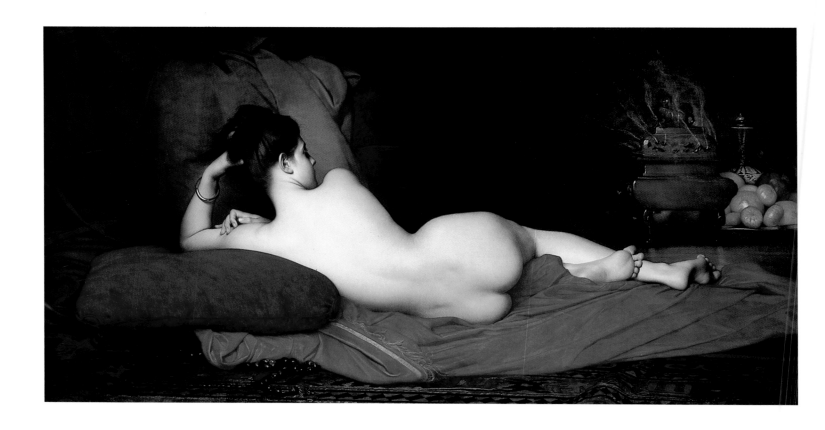

Jean Léon Gérôme
The Chariot Race
1876

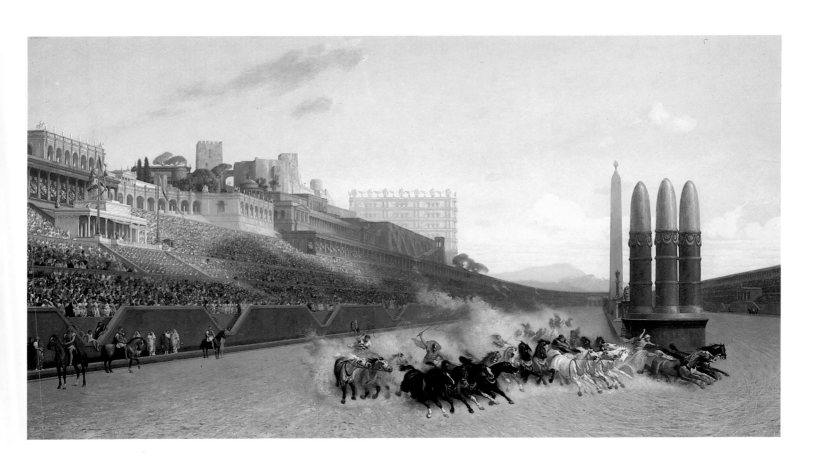

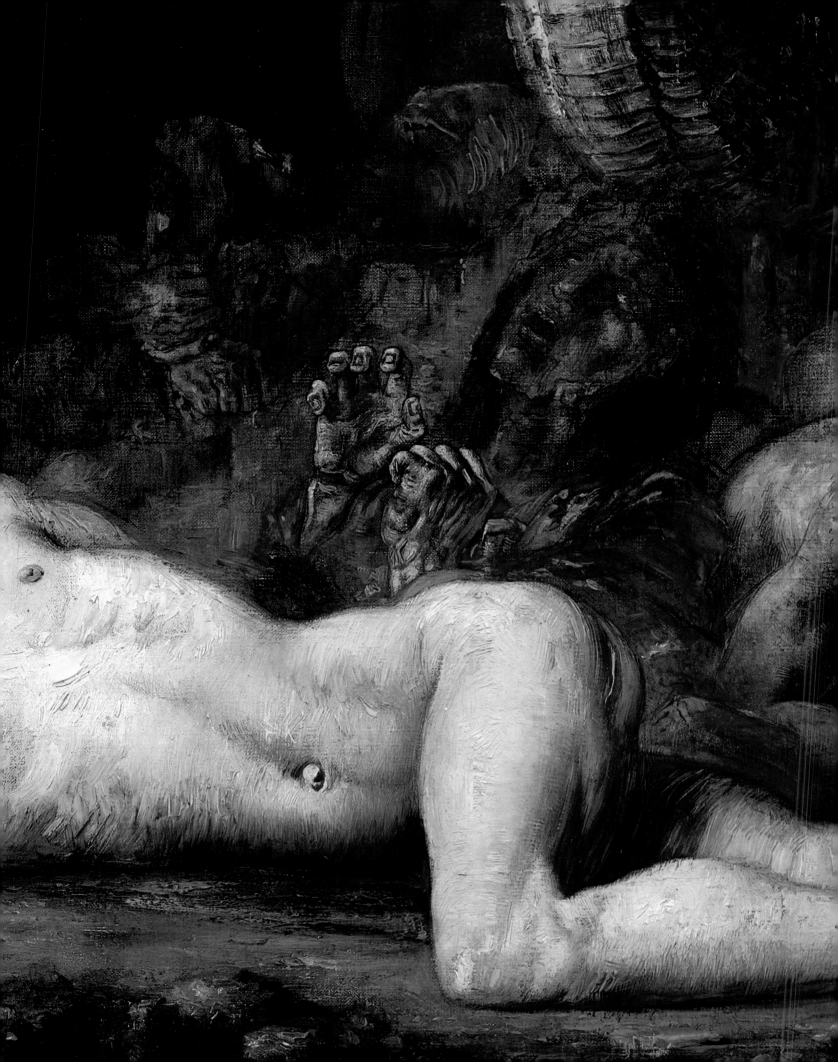

MOREAU'S EXOTIC IMAGINATION

After a six-year absence, Gustave Moreau reappeared at the Salon of 1876 with two enormous – and enormously successful – paintings, *Hercules and the Hydra* and *Salome Dancing Before Herod* (Musée Gustave Moreau, Paris). In each, terror and treachery abound; in the *Hercules* especially, Moreau's taste for the ghoulish is given nearly free reign. The bodies of the dead and dying emerge from an almost primordial ooze of brown paint. Above the desolation looms its mistress, the Hydra, whose heads were modeled not only on those of live snakes studied by Moreau at the Paris zoo, but also on representations of cobras he found in Egyptian art. Only two figures in the composition are conventionally finished: Hercules, standing amidst the carnage with club in hand; and his fallen predecessor, lying dead at the base of the Hydra. The remainder of this large picture is left in a state that resembles more an oil sketch than a finished Salon painting.

In many ways, Moreau's achievement was somewhat diminished by the fact that he, along with Puvis de Chavannes, was *the* great artist of the Salon during the period when most artists with real energy and quality had already deserted this immense annual exhibition. Moreau was fifty years old and a successful artist, living in grand style in an enormous studio filled to overflowing with his own abundant oeuvre. Even today, one can get a sense of the sheer energy and intensity of Moreau in a visit to his Paris studio, which was "embalmed" as a museum at his death.

What the studio reveals is not really the work of a Salon artist but a restless genius whose art seems to have leapt out of the pages of Victor Hugo's visionary poetry and whose talents found their most brilliant expression in watercolors, drawings, and experimental works in every conceivable medium from tempera to wax. Moreau was unquestionably among the few great painters of the Salon who routinely exhibited works on paper. *Inspiration* is among Moreau's finest and most well preserved watercolors of the early 1890s. The allegorical figure of inspiration is embodied by two figures, one a conventional muse whose jeweled drapery covers her body and barely hides her lyre; the other is a red-winged angel with her eyes closed and her head turned away from the light of the enameled sun rising in the distant landscape. The mating swans, the surreal, orchidlike flowers, the lapis lazuli mountains, and the great regular trunks of the trees create a setting comparable to those evoked in the contemporary poetry of Stephane Mallarmé, whose work was surely known to the worldly and literate Moreau.

Moreau was fascinated with the classical and biblical worlds, and the myths and tales from these two great traditions provided him with endless paintable material. Yet, his unorthodox technique and exotic, late Romantic treatment of these texts, link him with the Symbolist artists who began to dominate Europe in the closing decades of the nineteenth century. The generation of the *fin de siècle*, obsessed as it was with the fears of decadence, decay, and death, adopted the elderly Moreau as a kindred spirit. As an old man, he became a respected teacher and advisor to young artists. Among his many students were Henri Matisse and Georges Rouault. Matisse studied with Moreau during the 1890s when *Inspiration* was made, and the lessons he learned from this master colorist he never forgot. Moreau's closest, most intense student and the first curator of the Moreau museum in Paris was Rouault. His jeweled Pierrots and glowing scenes from the life of Christ seem to follow logically from the fertile visual imagination of his mentor.

Gustave Moreau
Hercules and the Hydra
1875/76

Gustave Moreau
Inspiration
c. 1893

PAINTERS OF RURAL LIFE

The Salons of the 1880s became increasingly irrelevant. Dealer showrooms expanded dramatically both in number and accessibility, private exhibitions staged by groups of artists were held at regular intervals in Paris, the French state opened a permanent museum of contemporary painting in the Luxembourg Gardens in 1874, the year of the first Impressionist exhibition. The fact that contemporary art was now so widely available did not in any way discourage the promoters of the Salons; the exhibitions of the 1880s were larger and more expensively installed than they had been at the height of their importance in the late eighteenth and early nineteenth centuries.

Most evaluations of modern painting in France during the late nineteenth century stress the Salon's oppressive veneration of historical subjects, but, when one reviews the actual contents of the Salons during the late years, one finds many paintings of contemporary life, both rural and urban. Often, these paintings were made as improvements upon Impressionist and Post-Impressionist pictures, which, by the 1880s, had become prolific. Also, one must keep in mind that works by Edouard Manet, Claude Monet, Auguste Renoir and other avant-garde artists were admitted to the Salon throughout the decade.

The three paintings reproduced here were all made by prominent Salon painters in the mid-1880s, and all of them represent rural life. The only one actually exhibited at a Salon was Jules Breton's *Song of the Lark*, a very popular painting by one of the best-known painters of rural France. Breton's career got off to a dramatic start in the 1850s, when his immense peasant genre pictures received considerably more favorable notice than those of the older – and more gifted – Jean François Millet (pp. 50 and 86). Breton continued to prosper in the 1860s, '70s, and '80s, when many of his pictures were commissioned in advance of their execution or painted in replica for the international market. *The Song of the Lark* is perhaps the most famous painting by Breton outside of France. It was snapped up at the Salon of 1885 by the American millionaire James J. Hill of Saint Paul, Minnesota, who sold it to Chicagoan Henry Field, from whose collection it entered the Art Institute in 1894, less than a decade after its initial exhibition at the Salon.

The subject of *The Song of the Lark* is not immediately evident. An attractive, young peasant woman in the fullness of her life stands silently in the flat fields of Breton's native Normandy as the sun sets, listening to the song of a lark. The lark itself is so small and so distant as it flies through the evening sky that, were it not for the title, most viewers would never be encouraged to find it. However, every search for the lark is ultimately successful, and when we find it, the silence of the painting is interrupted by the tiny fleck in the sky, whose gentle song, with its unmistakable message of hope, we can almost hear. Breton himself had become increasingly interested in effects of light and atmosphere as his career continued, and he could never have conceived of such a composition, with its figure lit from behind, in the earlier years of his career. Indeed, Breton, too, for all his aesthetic conservatism, was moved to expand his own art by the example of the young Impressionists, whose art he despised.

The two smaller paintings in this group were painted by artists whose careers were codified at the Salon. Jean Cazin exhibited in the Salons between

1876 and 1883, at which time he became prosperous enough to avoid the exhibitions. He was known for haunting, melancholic landscapes populated by peasant figures or by biblical-historical figures, often in peasant costume. In this painting, Cazin represented the Greek pastoral poet Theocritus and his muse in a setting far from their native Greece. The poet, from the third century B.C., records his inspiration perched upon a fallen log on a nineteenth-century farm in the north of France. Cazin was trained as an artist to observe nature carefully, but also to copy it only from memory; a quality of remove from actual nature persists in all of his paintings, whether made for the Salon or, as is the case with *Theocritus*, for private sale.

Pascal Dagnan-Bouveret, a Parisian, devoted himself to the representation of life in Brittany and exhibited at the Salons throughout the last two decades of the nineteenth century. His most recognized painting, *The Pardon in Brittany*, executed in several versions, was made for the Salon of 1887 and sent to the Universal Exhibition in Paris in 1889. *Woman from Brittany*, a small panel painted in preparation for a large, multifigural Salon painting, is a portrait of a Breton peasant wearing her Sunday best. The carefully observed volumes and superbly painted drapery derive generally from Flemish Renaissance precedents; Dagnan-Bouveret clearly admired both the imagery and earnest craftsmanship evident in the works by artists like Hans Memling, Rogier van der Weyden, and Dirk Bouts. These qualities also appealed to many international collectors, and most works by the painter had greater success in the marketplace during his lifetime than they have had since his death.

Jules Breton
The Song of the Lark
1884

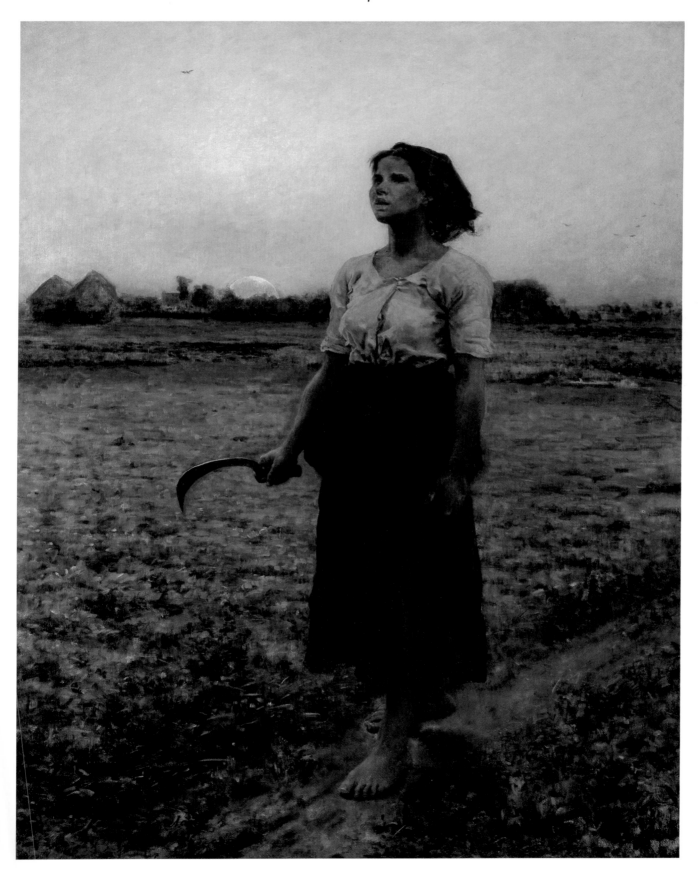

Jean Charles Cazin
Theocritus
c. 1885/90

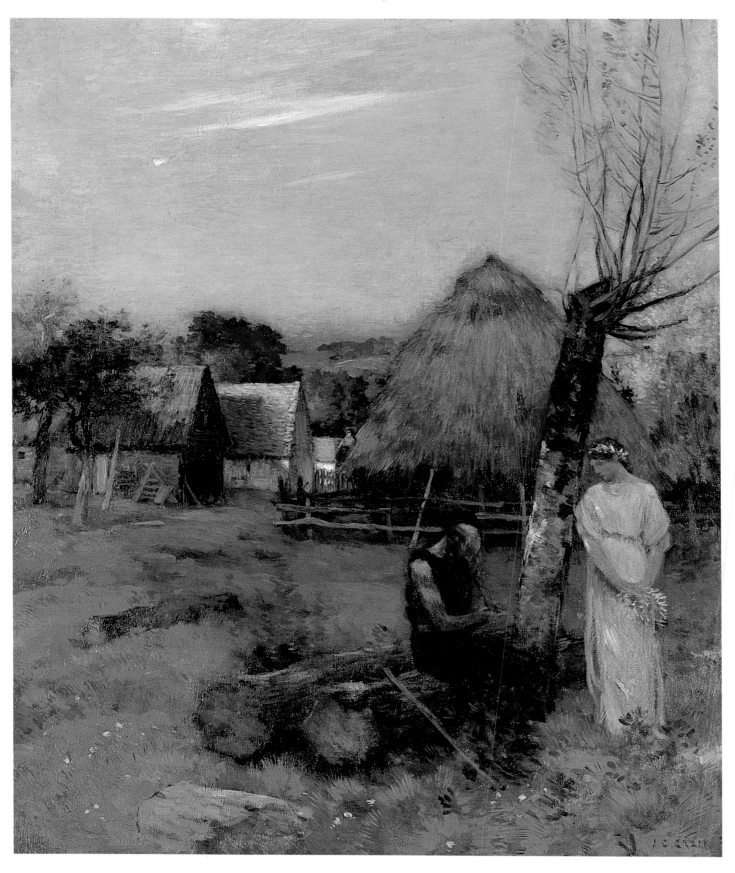

Pascal Dagnan-Bouveret
Woman from Brittany
1886

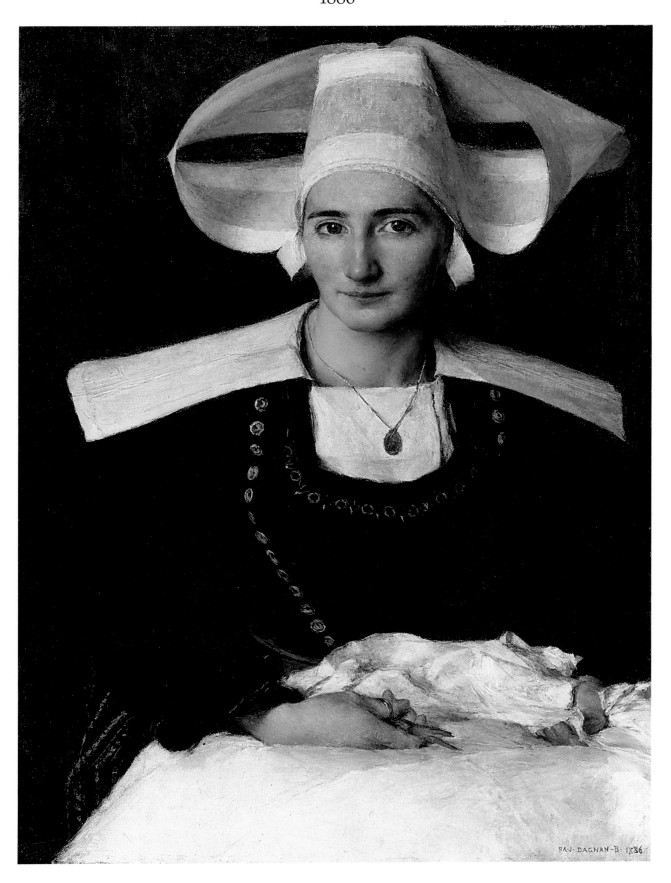

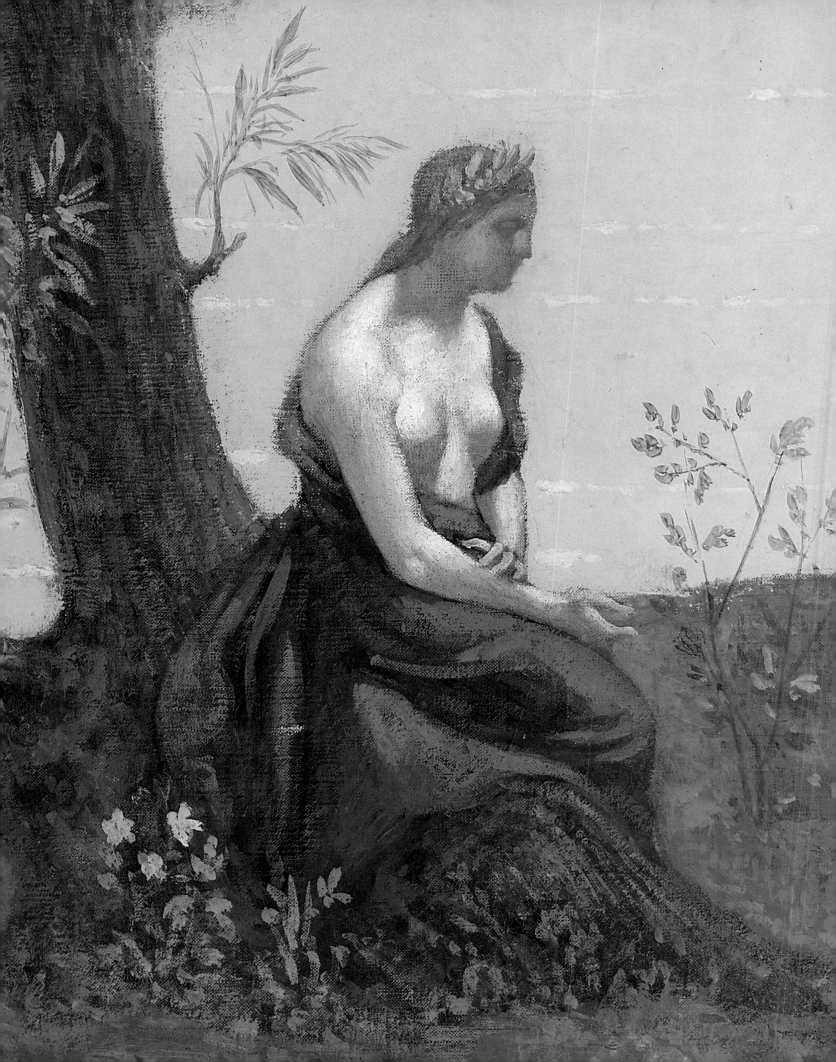

PUVIS AND THE SALON

Although the name of Puvis de Chavannes is anything but a household word in either France or America today, during the last two decades of his life, he was the most famous painter in France. His immense mural paintings adorned museums, churches, and libraries throughout France, and his renowned staircase mural at the Boston Public Library was among the aesthetic triumphs of art patronage in America during the Gilded Age. Puvis, as he was called during his lifetime, obliged an adoring public by exhibiting annually at the Salon and by making for the art market replicas, reductions, and freely composed, deliberate "copies" of his famous paintings.

These two paintings by Puvis date from the 1880s, when his celebrity was at its peak. The larger and more important of the works is *The Sacred Grove*, a painted reduction of a huge canvas executed for the Musée des Beaux-Arts in Lyons, France, and exhibited in the Salon of 1884. Its subject is loosely mythological. In the center of the composition, Puvis chose to represent the three Plastic Arts — painting, sculpture, and architecture — surrounded by the nine muses of classical antiquity and three androgynous youths making garlands. The figures of the muses are difficult to precisely identify, and this was clearly intentional. Unlike Jean Léon Gérôme, who was anxious that his classical subjects be well researched and accurately depicted (p. 101), Puvis was more interested in a general, poetic evocation of the past. Just as he rejected the "pictorial archeology" of Gérôme, Puvis also deliberately avoided the crystalline realism of that hallowed Salon painter. Rather, he adopted a decorative flatness, often associated with Roman wall paintings, and chose subdued, almost chalky colors that suggest those ancient surfaces. In *The Sacred Grove*, figures are carefully placed in a landscape that is, itself, a study in harmonious proportions largely derived from the dimensions of the classical Golden Section. With its geometrically structured order, airless tranquility, and timelessness, the painting appealed directly to the visual imagination of the young Georges Seurat, who saw the larger version at the Salon of 1884, just before he began work on *Sunday Afternoon on the Island of La Grande Jatte*, the great masterpiece in the Art Institute.

Although later in date, *The Fisherman's Family* has earlier origins in Puvis's oeuvre, being a reduced variation on a painting exhibited by the artist at the Salon of 1875. Unfortunately, that original canvas, kept by the artist throughout his life and sold only in 1901 to the Staatliche Gemäldegalerie in Dresden, was destroyed during World War II, so our knowledge of its composition comes only from photographs. The later and smaller painting shown here was executed in a looser, more abstract manner, with less attention given to the shading of the figures. Its surface, both drier and rougher than that of the Salon painting from which it derives, resembles that of classical and Renaissance fresco decorations, which Puvis sought to emulate in his finest works.

Puvis's paintings were admired by virtually every major artist of the nineteenth century. Seurat and Redon were each moved to emulate aspects of his composition and surface treatment, and Gauguin often looked at photographs of Puvis's paintings when he needed inspiration in the distant reaches of Tahiti during the last decade of the nineteenth century. Even the great twentieth-century artist Henri Matisse, whose work is so often considered to be about color, owed a tremendous debt to Puvis's flat surfaces and simple, clearly organized compositions.

Detail of
The Sacred Grove

Pierre Puvis de Chavannes
The Sacred Grove
1884-89

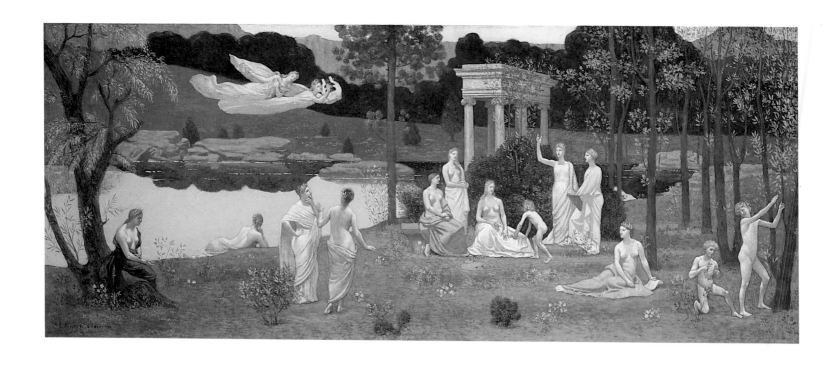

Pierre Puvis de Chavannes
The Fisherman's Family
1887

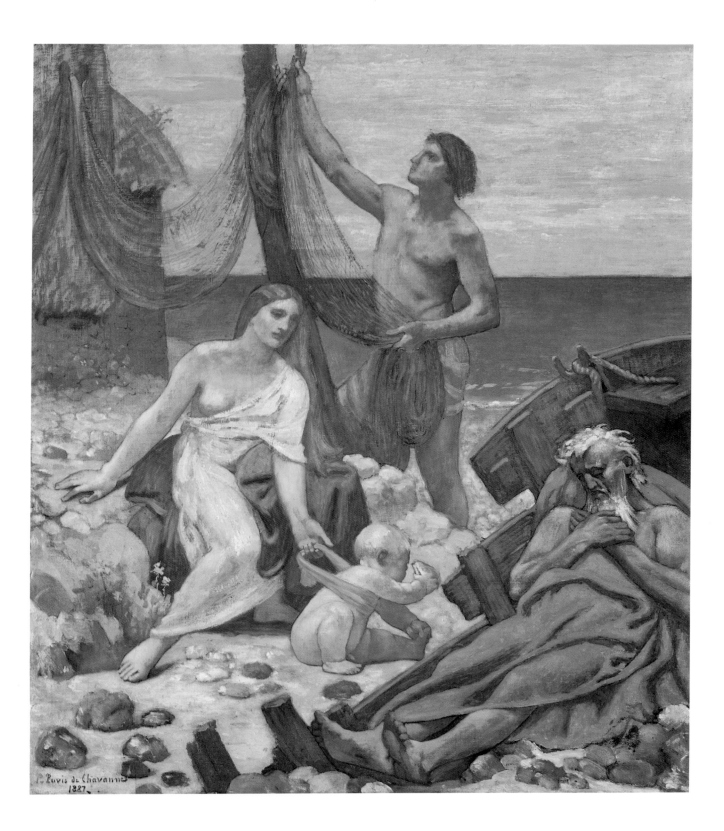

CHECKLIST

Bazille, Frédéric
1841-1870

Self-Portrait
1865-66
Oil on canvas, 108.9 x 72.1 cm
Mr. and Mrs. Frank H. Woods restricted gift
in memory of Mrs. Edward Harris Brewer,
1962.336
pp. 74 (ill.), 75

Landscape at Chailly
1865
Oil on canvas, 81 x 100.3 cm
Charles H. and Mary F. S. Worcester
Collection, 1973.64
pp. 78, 80 (ill.)

Boilly, Louis Léopold
1761-1845

The Arcades at the Palais Royal
1803-04
Pen and black ink with black and gray wash,
over traces of graphite, on ivory paper,
365 x 457 mm
Worcester Sketch Fund, 1963.558
pp. 11, 12 (ill.)

The Movings
1822
Oil on canvas, 73 x 92 cm
Harold Stuart Fund, 1982.494
pp. 10 (det.), 11, 13 (ill.)

Boudin, Eugène
1824-1898

Approaching Storm
1864
Oil on panel, 36.6 x 57.9 cm
Mr. and Mrs Lewis Larned Coburn Memorial
Collection, 1938.1276
pp. 48 (det.), 49, 52 (ill.)

Breton, Jules
1827-1906

The Song of the Lark
1884
Oil on canvas, 110.6 x 85.8 cm
Henry Field Memorial Collection, 1894.1033
pp. 106 (det.), 107, 109 (ill.)

Cazin, Jean Charles
1841-1901

Theocritus
c. 1885/90
Oil on canvas, 74 x 60.5 cm
Potter Palmer Collection, 1922.401
pp. 108, 110 (ill.)

Champmartin, Charles Emile
1797-1883

*After Death, Study of a
Severed Head*
c. 1818/19
Oil on canvas, 45.6 x 55.6 cm
A. A. Munger Collection, 1937.502
pp. 14 (det.), 15, 17 (ill.)

Corot, Jean Baptiste Camille
1796-1875

View of Genoa
1834
Oil on paper mounted on canvas,
29.5 x 41.7 cm
Mr. and Mrs. Martin A. Ryerson Collection,
1937.1017
pp. 24 (ill.), 25

Bathing Nymphs and Child
1855/60
Oil on canvas, 82.6 x 100.3 cm
Mr. and Mrs. W. W. Kimball Collection,
1922.4454
pp. 69, 70 (ill.)

*Souvenir of the Environs of
Lake Nemi*
1865
Oil on canvas, 98.4 x 134.3 cm
Bequest of Florence S. McCormick, 1979.1280
pp. 68 (det.), 69, 71 (ill.)

Interrupted Reading
c. 1870
Oil on canvas on board, 92.5 x 65.1 cm
Potter Palmer Collection (bequest of Berthé
Honoré Palmer), 1922.410
pp. 92 (det.), 93-94, 95 (ill.)

Courbet, Gustave
1819-1877

Seated Model Reading in a Studio
c. 1853
Charcoal on ivory wove paper, 562 x 390 mm
Simeon B. Williams Fund, 1968.163
pp. 26 (ill.), 27

Mère Gregoire
1855 and 1857-59
Oil on canvas, 129 x 97.5 cm
Wilson L. Mead Fund, 1930.78
pp. 30 (ill.), 31

The Rock at Hautepierre
1869
Oil on canvas, 80.2 x 100.3 cm
Emily Crane Chadbourne Fund, 1967.140
pp. 78, 81 (ill.)

Dagnan-Bouveret, Pascal
1852-1929

Woman from Brittany
1886
Oil on canvas, 38.5 x 28.5 cm
Potter Palmer Collection, 1922.445
pp. 108, 111 (ill.)

Daumier, Honoré
1808-1879

The Three Judges
c. 1855/58
Pen and black ink and watercolor, over black
chalk, on ivory laid paper, 300 x 465 mm
Helen Regenstein Collection, 1968.160
pp. 41-42, 43 (ill.)

The Print Collector
c. 1857/63
Oil on cradled panel, 42.3 x 33 cm
Gift of the Estate of Marshall Field, 1957.305
pp. 40 (det.), 41, 43 (ill.)

Family Scene
c. 1865
Pen and black ink with gray wash, on ivory
wove paper, 214 x 205 mm
Helen Regenstein Collection, 1965.633
pp. 42, 45 (ill.)

Degas, Edgar
1834-1917

Self-Portrait
1857
Etching printed in black-brown ink on white
laid paper, 230 x 143 mm
Fair Collection, 1932.1294
pp. 46 (ill.), 47

The Young Spartans
1859-60
Oil on canvas, 97.4 x 140 cm
Charles H. and Mary F. S. Worcester Fund,
1961.334
pp. 38 (ill.), 39

Four Studies of a Jockey
1866
Brush and black essence, heightened with
white gouache, on tan wove paper coated
with brown essence, 450 x 315 mm
Mr. and Mrs. Lewis Larned Coburn
Memorial Collection, 1933.469
pp. 64, 66 (ill.)

Gentleman Rider
1866/70
Brush with black ink, heightened with
gouache, over graphite, on brown pink wove
paper, laid down, 440 x 280 mm
Gift of Mrs. Josephine Albright, 1967.240
pp. 64, 67 (ill.)

Delacroix, Eugène
1798-1863

*Combat Between the Giaour and
Hassan in a Ravine*
1826
Oil on canvas, 59.6 x 73.4 cm
Gift of Mrs. Bertha Palmer Thorne, Mrs.
Rose Movius Palmer, Mr. and Mrs. Arthur
M. Wood, and Mr. and Mrs. Gordon Palmer,
1962.966
pp. 18 (ill.), 19

The Lion Hunt
1861
Oil on canvas, 76.5 x 98.5 cm
Potter Palmer Collection, 1922.404
pp. 32 (ill.), 33

**Diaz de la Peña,
Narcisse Virgile**
1807-1876

Pond in the Woods
1862
Oil on canvas, 68 x 89.8 cm
Mr. and Mrs. W. W. Kimball Collection,
1922.4455
pp. 34 (det.), 35, 37 (ill.)

Doré, Gustave
1832-1883

The Forest/Alpine Scene
1865
Oil on canvas, 195.5 x 130 cm
Gift of Julius H. Weitzner, Inc., 1967.588
pp. 72 (ill.), 73

Fantin-Latour, Henri
1836-1904

Portrait of Edouard Manet
1867
Oil on canvas, 117.5 x 90 cm
The Stickney Fund, 1905.207
pp. 82 (ill.), 83

Still Life: Corner of a Table
1873
Oil on canvas, 96.4 x 125 cm
Ada Turnbull Hertle Fund, 1951.226
pp. 96 (ill.), 97, front and back covers.

Géricault, Théodore
1791-1824

*Sketches for a Cavalry Battle,
Mounted Officer*
c. 1813/14
Folio 59 from an album of drawings
assembled from what may have been two
separate sketch books (1818-19 and 1812-14).
Pen and brown ink, brown wash, and
traces of graphite on ivory wove paper,
224 x 288 mm
Margaret Day Blake Collection, 1947.35
pp. 15, 16 (ill.)

Gérôme, Jean Léon
1824-1904

Portrait of a Lady
1851
Oil on canvas, 92.6 x 73.7 cm
Silvain and Arma Wyler Foundation,
Restricted Gift, 1964.338
pp. 28 (ill.), 29

The Chariot Race
1876
Oil on canvas, 86.3 x 156 cm
George F. Harding Collection, 1983.380
pp. 98 (det.), 99, 101 (ill.)

Guigou, Paul Camille
1834-1871

*The Banks of the River Durance
at Saint-Paul*
1864
Oil on canvas, 62 x 148 cm
Searle Family Trust, 1986.137
pp. 49, 51 (ill.)

**Ingres, Jean Auguste
Dominique**
1780-1867

Portrait of Charles François Mallet
1809
Graphite on buff wove paper, 268 x 211 mm
Charles Deering Collection, 1938.166
pp. 21, 22 (ill.)

*Amédée-David, The Marquis
of Pastoret*
1823-26
Oil on canvas, 103 x 83.5 cm
Dorothy Eckhart Williams Bequest, Robert
Allerton Purchase Fund, Bertha E. Brown
Fund, Major Acquisitions Fund, 1971.452
pp. 20 (det.), 21, 23 (ill.)

Jongkind, Johann Barthold
1819-1891

Entrance to the Port of Honfleur
1864
Oil on canvas, 42.2 x 56.2 cm
Louise B. and Frank H. Woods Purchase
Fund (in honor of The Art Institute's
Diamond Jubilee), 1968.614
pp. 49, 53 (ill.)

Lefebvre, Jules Joseph
1836-1911

Odalisque
1874
Oil on canvas, 102.4 x 200.7 cm
George F. Harding Collection, 1983.381
pp. 99, 100 (ill.)

Manet, Edouard
1832-1883

Still Life with Carp
1864
Oil on canvas, 81.5 x 99.9 cm
Mr. and Mrs. Lewis Larned Coburn
Memorial Collection, 1942.311
pp. 54 (det.), 55, 56 (ill.)

Departure from Boulogne Harbor
1864/65
Oil on canvas, 73.6 x 92.6 cm
Potter Palmer Collection, 1922.425
pp. 55, 57 (ill.)

The Races at Longchamps
1864
Oil on canvas, 43.9 x 84.5 cm
Potter Palmer Collection, 1922.424
pp. 62 (det.), 63-64, 65 (ill.)

The Mocking of Christ
1865
Oil on canvas, 190.3 x 148.3 cm
Gift of James Deering, 1925.703
pp. 58 (det.), 59-60, 61 (ill.)

Civil War
c. 1871
Lithograph printed in black on wove sheet,
490 x 608 mm
John H. Wrenn Memorial, 1946.342
pp. 90 (ill.), 91

Millet, Jean François
1814-1875

Bringing Home the Newborn Calf
1864
Oil on canvas, 81.5 x 99.9 cm
Henry Field Memorial Collection, 1894.1063
pp. 49, 50 (ill.)

In the Auvergne
1866/69
Oil on canvas, 81.1 x 100 cm
Henry Field Memorial Collection, 1922.414
pp. 84 (det.), 85, 86 (ill.)

The Old Mill
1866/69
Pen, black ink, and pastel, 408 x 483 mm
Gift of John Wentworth, 1942.307
pp. 85, 87 (ill.)

Moreau, Gustave
1826-1898

Hercules and the Hydra
1875/76
Oil on canvas, 179.3 x 154 cm
Gift of Mrs. Eugene A. Davidson, 1964.231
pp. 102 (det.), 103, 104 (ill.)

Inspiration
c. 1893
Watercolor, ink, and graphite, 287 x 190 mm
Gift of Mrs. Wesley M. Dixon, Jr., 1985.596
pp. 103, 105 (ill.)

Pissarro, Camille
1830-1903

The Banks of the Marne in Winter
1866
Oil on canvas, 91.8 x 150.2 cm
Mr. and Mrs. Lewis Larned Coburn
Memorial Fund, 1957.306
pp. 76 (det.), 77, 79 (ill.)

Puvis de Chavannes, Pierre
1824-1898

The Sacred Grove
1884-89
Oil on canvas, 93 x 231 cm
Potter Palmer Collection, 1922.445
pp. 112 (det.), 113, 114 (ill.)

The Fisherman's Family
1887
Oil on canvas, 82.5 x 71.8 cm
Mr. and Mrs. Martin A. Ryerson Collection,
1915.227
pp. 113, 115 (ill.)

Redon, Odilon
1840-1916

Landscape with Oak
1868
Charcoal with estompe, on tan paper,
535 x 755 mm
Ada Turnbull Hertle Fund, 1966.349
pp. 88 (ill.), 89

Rousseau, Théodore
1812-1867

Springtime
c. 1860
Oil on cradled panel, 42.9 x 56.1 cm
Henry Field Memorial Collection, 1894.1066
pp. 35, 36 (ill.)